THE
TREASURY
OF
FLOWERS

Alice M. Coats

THE TREASURY OF FLOWERS

Such pretie things would soon be gon
If we should not them so remembre.

———

Phaidon
IN ASSOCIATION WITH
THE ROYAL HORTICULTURAL
SOCIETY

PHAIDON PRESS LIMITED
5 Cromwell Place · London, SW7 2JL

—

First published 1975
© *1975 by Phaidon Press Limited*
ISBN 0 7148 1674 4

—

Printed in The Netherlands by
Drukkerij de Lange/van Leer NV
Deventer

Contents

Acknowledgements

—

One cannot exactly thank a library or an institution, but the author wishes to express her gratitude to the Directors and long-suffering librarians of the following establishments, with heartfelt appreciation of their helpfulness and tolerance. The Royal Horticultural Society; the British Museum (Natural History); the Birmingham, Birmingham Reference and Birmingham University Libraries and the Wellcome Institute for the History of Medicine. Reverent thanks are also due to the Vatican Library and to the National Library of Vienna; and also to the numerous private individuals who, like suspects arrested by the police, have 'assisted me in my enquiries'.

It should perhaps be mentioned that the copy of a book examined by the author was not always the copy from which the reproduction was ultimately made. Plates were reproduced by kind permission from volumes in the collections of the following authorities:

British Library 63
British Museum 10
British Museum (Natural History) 20, 21, 22, 30, 31, 42, 75, 81, 82
National Library of Vienna 1
Royal Botanic Gardens, Kew 5, 8, 11, 41, 44, 76
University of Birmingham 2
Vatican Library 15, 16
Victoria and Albert Museum 9
Wellcome Institute 13, 43

All the remainder were reproduced from works in the Lindley Library of the Royal Horticultural Society.

THE TREASURY OF FLOWERS

The Small Flower-Book—an Apologia

The great folio masterpieces of floral illustration—the Ehrets, the Redoutés and the Bauers—are renowned, and rightly so; but their splendour has tended to eclipse the numerous smaller flower-books, which have been perhaps unfairly neglected. These lesser works have their own merits and their own qualities, and deserve an overdue recognition. A drawing small in size is not necessarily small in conception, and there is room for as much skill on an octavo page as on a folio one, though the latter is more immediately impressive. The object of this book is to bring to light some of these forgotten treasures; though even here, the *real* miniatures—exquisite plates hardly larger than a postage-stamp—have had to be excluded.

Almost at the start of plant-illustration the theory arose that the flowers should be represented as near as possible to the natural size; hence the necessity for a large format. Fuchs led the way with his great *De Historia Stirpium* in 1542, and though his example in this respect was not immediately followed, from the seventeenth century onwards the folio or large quarto flower-book became the rule rather than the exception. But not everyone could afford these great handsome volumes, nor did the subject always require them. Even in the sixteenth century, that age of massy learning when it seems to have been beneath the dignity of a herbalist to be seen with anything less ponderous than a family bible, there were already a number of books of quite small, even miniature, size. On the whole, however, few herbals would qualify as small flower-books, though the woodcuts that illustrated them were small; it was at the end, rather than the beginning, of the great age of floral illustration that the little book came into its own.

Mere size, after all, is no criterion of importance. As a gardener loftily remarked about Linnaeus' folio treatise on the banana, 'these books are made for pompe, to fill a library, and more for outward show than real use etc., having very little within, as many I could name . . .' On the other hand,

Michaux's *Flora Boreali Americana* (1803), the first comprehensive flora of North America and of great historical importance, was of no great size, though its two unassuming paper-covered volumes were illustrated by Redouté. Possibly Michaux could not afford a more ambitious production; he had been impoverished by the French Revolution, and moreover was spending all his spare time and money helping his formerly wealthy patron M. le Monnier, who was now poor, sick and old. After le Monnier's death Michaux left the manuscript in charge of his son while he joined Captain Nicolas Baudin's scientific expedition to Australia in 1800; he died in Mauritius two years later, and his book, edited by others, was published posthumously.

Neither is size of book commensurate with size of subject—indeed, the biggest topics seem to evoke the smallest books. The family of the palms contains many species of great economic importance and large size—trees topping 125 feet or with leaves forty feet in length—yet all the books available to the nineteenth century student of the subject were, with two exceptions, of octavo size or less. The explorer Alfred Russell Wallace, whose scientific achievements and towering mental stature surpassed the dignity of the stateliest oreodoxa, wrote an interesting little monograph on the palms of the Amazon, the illustrations of which, lithographed by Fitch from the author's original pencil sketches, were actually too small for reproduction here.

It must be admitted, however, that small editions of illustrated works originally published as folios are usually, though not inevitably, failures; Handasyde Buchanan, an expert on the subject, once called them 'little brothers that nobody wants'. Robert Furber's folio *Twelve Months of Flowers*, with its bouquets of seasonal flowers by the Flemish artist Pieter Casteels, was re-issued in a smaller form four years later as *The Flower-Garden Display'd*; but the original plates had been copied without understanding by an engraver unfamiliar with flowers, and the result, though still pleasant, was often meaningless and confused. The octavo editions of Redouté's *Roses* and Audubon's *Birds of America*, and the 'lottery' edition of Thornton's *Temple of Flora*, cannot be compared with the great originals; and there are other examples. It seems useless to try to cheapen or popularize a work originally conceived on a noble scale. In the case of William Curtis's 'Abridgement' to his great *Flora Londinensis*, however, the 'little brother' was not so much inferior as delicate and sickly; Curtis never managed to

rear it beyond the first twelve parts. By that time he was already absorbed in a new and momentous venture—the publication of the *Botanical Magazine*.

The Periodicals

In the *Botanical Magazine* 'the most ornamental foreign plants cultivated in the open ground, the greenhouse and the stove' were to be illustrated by new figures 'drawn always from the living plant and coloured as near to nature as the imperfection of colouring will admit'. It was also to afford 'the best information respecting their culture—in fact, a work in which Botany and Gardening . . . might happily be combined'. It was issued in monthly parts, each containing three coloured plates and costing a shilling, and was an immediate success; 3,000 copies of the first part were sold, where the parts of the *Flora Londinensis* sold only 300. Curtis himself said that the *Flora Londinensis* brought him praise, but the *Botanical Magazine* brought him pudding. For a long time it kept its largely horticultural character; Loudon in 1827 remarked 'We regret to see such things as picotees and common carnations figured in this work, which, in our opinion, ought to be devoted to elegant science rather than to floral amusement.' But a change was already at hand, and under the newly established editorship of W. J. Hooker, 'elegant science' came into its own; botanical details were added to the plates, the subjects became more wide-ranging and the text more scholarly. With fluctuating fortunes and under various editors the magazine has survived to this day, the oldest periodical of its sort in the world; and it continued to have plates coloured by hand till 1948. One plate from each of its volumes would more than fill this book.

William Curtis, whose pioneering enterprise in this matter led to some surprising results, was the eldest son of a tanner in the little village of Alton in Hampshire, and was apprenticed as a youth to his apothecary grandfather. He received his first instructions on plants from a local ostler, who was a keen amateur botanist. His father thought he spent too much time on natural history—he had a garden full of 'weeds', the food-plants of certain insects—so he sent him to an apothecary in London, to be out of reach of temptation. There is a story that his new master was shocked to find among William's possessions an engraving of a common nettle, for which he had paid three guineas. As soon as his circumstances permitted, however, Curtis abandoned physic for botany, and supported himself,

sometimes precariously, by writing and teaching. He established a botanic garden at Lambeth, and later moved to Brompton, where, it was reported, 'men from the other end of the town call on him *in their coaches* to desire private lectures for grown gentlemen'. (The American John Torrey, later a notable botanist in his own country, was among his students.) Curtis was a stocky man with a short neck and an open cheerful countenance; a friendly, unassuming person, whom everybody liked. He died in 1799, when his magazine had reached its thirteenth volume; its ownership passed to his nephew and son-in-law Samuel Curtis, who retained the copyright till 1845.

The success of the *Botanical Magazine* attracted many imitators. It is sometimes difficult to distinguish between a periodical and a serially published book, especially when the former ran only to one or two volumes, and the latter, like Sowerby's *English Botany*, to thirty-six. But the subject of a book is finite—Sowerby had to stop at last, when the English flora was exhausted—whereas a periodical is intended to continue for as long as it has public support. Under this definition, one can fairly reckon thirty botanical or horticultural commercial periodicals that came, and mostly went, between the launching of the *Botanical Magazine* and 1850. Some ran only to a single volume, some to twenty or thirty; a few, in name at least, still continue. Each had its individual character, but most of them were directed to the amateur rather than the professional botanist or gardener. Only Hooker's *Botanical Miscellany*, later to reappear as the *Journal of Botany*, was crammed with information undeniably and exclusively botanical. Almost all were of octavo size, and almost all had coloured plates, for in view of the competition it would have been courting disaster to launch a magazine without them. Even the *Journal of Botany* and the *Journal of the Horticultural Society* had colour plates in their first issues, though they quickly settled down to sober black and white.

Elsewhere the fever was almost equally high, and America, France, Belgium and Germany all had similar periodicals. Plates and articles from the English journals were frequently copied by the Continental ones—with or without acknowledgement. There was then a true Common Market in horticulture, and the Belgian *Flore des Serres* published articles in French, English and German. The demand from public and private gardeners for plant-novelties seems to have been insatiable, and nurseries, individuals and botanical institutions sent plant-collectors to every part of

the world. Even allowing for duplications, the number of plants (many since lost) depicted in these periodicals was astronomical—a positive explosion of flower-pictures; hence there is an unavoidable predominance of the period in this book.

The *Botanical Magazine*'s first competitor was the *Botanist's Repository*, started by H. C. Andrews in 1797. It was bigger than its progenitor but not better; a quarto, describing 'New and Rare plants *Only*', with bright and showy illustrations whose quality and draughtsmanship left much to be desired. Andrews, who describes himself as 'Botanical Printer and Engraver etc.', married Anne, the third of the twenty-one children of the nurseryman John Kennedy (a successful propagator), and most of the plants in the first five volumes were grown by the famous firm of Lee and Kennedy. After the sixth volume there was a break of two years; then publication was resumed and staggered on till the end of volume ten, which took ten years to complete, the journal then giving up the struggle.

A much more serious rival to Curtis was the *Botanical Register*, founded at the end of the Napoleonic Wars by the artist Sydenham Edwards, who after working for the *Botanical Magazine* for twenty-seven years broke away and started a periodical of his own. He survived this defection for only four years, but the *Register* continued to flourish till 1847. The standard both of plates and text was high; the *Botanical Magazine* suffered very much from its competition and the loss of so able an artist, and fell into a decline from which it did not recover till reinvigorated by Hooker in 1826.

The twenty volumes of Loddiges' *Botanical Cabinet*, each containing a hundred plates, began to appear in 1818, but were of a very different character; strictly speaking there was nothing botanical about either pictures or text. Like the early volumes of Andrews, this publication was the product of a nurseryman. It was modestly attributed to the firm of 'Conrad Loddiges and Sons' and the illustrations to George Cooke; but actually a large proportion of the drawings were made by the elder son, George Loddiges (with a delicacy natural in one whose hobby was the collection of humming-birds), and only engraved by Cooke. George Loddiges also wrote the text, which consisted chiefly of brief cultural directions and pious reflections, for Loddiges was a staunch Non-conformist. 'Surrounded as we are, and have been from our infancy', he wrote, 'by these choicest beauties of nature, we wish not to enjoy them alone. No! let them be diffused throughout the world; that all may

participate who have a mind capable of delighting in them.' An admirable nurseryman's sentiment; doubtless his piety was sincere, but it cannot be denied that the work was also an excellent advertisement for his firm.

Different again was the *Botanic Garden*, founded in 1825 by Benjamin Maund, chemist, printer and bookseller of the small town of Bromsgrove in Worcestershire. He was both author and editor, a practical gardener and a keen hybridist with a penchant for potentillas; his periodical, though published in London, was printed at his own Bromsgrove press. The vivid little four-to-a-page plates in the first six volumes were the work of Edwin Dalton Smith; the remaining seven were illustrated by a number of hands, many of them feminine, including Mrs Withers, Mrs Edward Bury and a Miss S. Maund. 'Whoever can afford to have infants, and wishes them to imbibe a taste for botany and gardening', wrote J. C. Loudon in the *Gardener's Magazine*, '. . . ought to spare 18/- a year for this work.'

These are only a few of the journals published in the early nineteenth century; their histories, and their repercussions on each other, offer a fascinating and neglected field for study. What was the reason for H. C. Andrews's apparent break with the firm of Lee and Kennedy? John Kennedy wrote the text for the first five volumes of the *Botanist's Repository*; the sixth was by A. H. Haworth, 'a botanist whose opinions were diametrically opposed to those of the former', and the remaining four by various hands, but after volume five, the firm, so prominent in the first parts, is no longer mentioned. Possibly Andrews's marriage to Anne Kennedy occurred about that time (1804, when the bride would have been about nineteen) and perhaps her family did not approve of the match. The defection of Sydenham Edwards to found his own journal was a severe blow to the *Botanical Magazine*, and much resented by the Curtis family, but William Curtis, Edwards's original patron and friend, had long been dead, and Edwards may have felt that after his many years of devoted service he was entitled to make a change. Again, there seems no reason why the *Register* should have stopped at volume thirty-three, unless one can surmise the death of its illustrator, Miss Drake; there was not in 1847 any new or special challenge from other journals. Loudon's *Gardener's Magazine* (1826)—a very educative production—was the first to be addressed to the working gardener rather than to the amateur botanist; at first it was more successful even than the *Botanical Magazine*, but declined after the appearance of Paxton and Harrison's *Horticultural*

Register in 1831. Paxton and Harrison soon split up, the latter to found the *Floricultural Cabinet* in 1833, and the former to establish the *Magazine of Botany* (1834–49). Unhappy Loudon, struggling with debt and ill health, roundly accused Paxton of plagiarism—and with some justification; but part of the decline of the *Gardener's Magazine* may have been due to the fact that it was illustrated only by black-and-white text engravings, while both of its competitors had coloured plates. Robert Sweet of the *British Flower Garden* was obviously bitterly jealous of John Lindley, then editing the *Botanical Register*, and had not a good word to say for him or for his artists. There is here a whole world of wriggling animalcula on which no microscope has yet been turned.

Botany for Ladies

Part, at least, of the success of so large a number of periodicals may have been due to the popularity of botany and flower-drawing as an occupation for ladies. Thornton in 1804 alluded scornfully to the *Botanical Magazine* as 'a drawing-book for ladies', and Loudon said of the cheaper, partly coloured edition of the *Botanical Cabinet*, 'To complete the colouring of these plates, and add M. S. notes in the margin, would be a charming and instructive female exercise.'

The pursuit was already fashionable in the mid-eighteenth century—as soon as Linnaeus's simplified arrangement by the number of styles and stamens had brought botanical classification, as Wilfrid Blunt puts it, within the range of any young lady who could count up to twelve. About 1749 the botanical artist Georg Ehret numbered among his pupils two Duchesses, two Countesses, and the daughters of three Dukes, an Earl and several Lords, besides other female ornaments of society; 'if I could have divided myself into twenty parts', he wrote, 'I could have had my hands full.' The autobiographical notes in which he gives this Don Juan-like list were written in 1758, so we do not learn whether Princess Charlotte of Mecklenburg-Strelitz, who came to England to marry George III in 1761, ever became his pupil; later on, she is said to have had lessons in flower-drawing from Francis Bauer. By the 1780s (when less occupied with child-bearing) the Queen was making a serious study of botany, coached by William Aiton of Kew and the Reverend John Lightfoot, botanical chaplain to the Dowager Duchess of Portland, and

was training her daughters to follow her example. 'There is not a plant in the gardens of Kew', wrote Robert Thornton, 'but has either been drawn by her gracious Majesty, or some of the Princesses, with a grace and skill that reflects on these personages the highest honours.' A number of botanical books were dedicated to the Queen, from Lord Bute's nine-volume *Botanical Tables*, about 1785, 'composed solely for the Amusement of the Fair Sex', to Thornton's *Temple of Flora* and Bauer's *Delineations of Exotick Plants*, where reference is made to 'the rapid progress her Majesty and the Princesses her daughters have made in the most difficult parts of that pleasing study' (i.e., botany.) Towards the end of her life Charlotte became the first royal patron of the Horticultural Society; William Hooker illuminated a page to receive her signature with a design of Strelitzias, the exotic South African Bird-of-Paradise Flower, which was named in her honour. (Queen Victoria's namesake flower, nearly fifty years later, was also a spectacular tropical water-plant.) Four varieties of apple, one brought by herself from Germany, were named after the Queen, and also, it is said, the dish 'apple Charlotte'.

With royalty to show the way, it is no wonder that botany and especially plant-drawing became accomplishments much sought after by every well-bred young lady; and the author of *Flora Bedfordiensis* (1798) re-marked 'that the fair daughters of Albion have evinced a zeal and ardour in botanical researches which has not only done the highest honour to themselves, but have eminently contributed to rescue these pursuits from unmerited reproach, and to impart to them, if not a superior value, at least a superior currency of fashion'. There were already a number of botanical books written by or for ladies, the first being J. J. Rousseau's *Lettres Elémentaires sur la Botanique* (1781) in the form of a series of in-structive epistles addressed to Mme Delessert; Bute's *Botanical Tables*, already mentioned, whose author assures us that being for the use of ladies 'no improper terms will be found in it'; and Maria Jackson's *Botanical Dialogues for the Use of Schools* in 1797. These were followed by six or seven others, the best-known being John Lindley's *Ladies' Botany* in 1834 and Jane Loudon's *Botany for Ladies*, 1842. Some of these works went into a number of editions, so the demand must have been great.

It was not only in Britain that females studied flowers. Prominent in France was Mme Brulart de Genlis, Marchioness de Sillery, who kept a tame botanist as a member of her household, and who published a two-

volume work, *La Botanique Historique et Littéraire*, in 1811. She and her compatriot 'Charlotte de la Tour' (Mme Louise Cortambert) were largely responsible for the dissemination in Europe of the oriental concept of the Language of Flowers. This was first introduced by Lady Mary Wortley Montagu, whose husband was ambassador to Constantinople in 1716–18; and though her celebrated Turkish Letters were not officially printed till 1763, they were privately circulated long before. She tells how in Turkey 'there is no colour, no flower, no weed, no fruit, herb, pebble or feather, that has not a verse belonging to it; and you may quarrel, reproach, or send letters of passion, friendship or civility, or even of news, without inking your fingers'. (She omits to mention that, in any case, few denizens of the harem could read or write.) The 'verses' were single lines or phrases rhyming with the name of the flower or object, and forming a sort of code for those who had the key. In the European Language of Flowers, as developed in France before the Revolution, rhymes or verses were not used; the symbolism depended entirely on the qualities or associations of the flowers themselves, sometimes rather arbitrarily assigned. The language never served any practical purpose—one could express 'Fly with me' but not 'Meet me at Euston under the clock'; it was as purely romantic as 'Gothick' architecture, but it caught the fancy of a sentimental age to an extraordinary degree. Charlotte de la Tour's book, translated into English in 1820, went into numerous editions, and was followed by dozens of little bibelots for the boudoir—albums, keepsakes and so on—full of poetry and piety, but often very elegant and pretty; minor qualities, but by no means to be despised.

Nearly a hundred years earlier America had a notable lady botanist—serious, accomplished and a pioneer. She was Jane Colden (1724–66), the daughter of Cadwallader Colden, the Governor of New York. Her father, a keen naturalist and a correspondent of Linnaeus, encouraged her to describe and draw plants, to learn Latin, and to make herself perfectly mistress of the Linnaean system. The family had taken up a grant of land about ten miles west of Newburgh (Orange County), and though botanizing there was neither very easy nor very safe, by 1758 Jane had compiled a manuscript describing four hundred local plants and their uses, illustrated by her own rather elementary drawings. Unfortunately it was never published: but her attainments were highly esteemed by visiting botanists and by her father's European correspondents. Some thirty-five

years after her death the manuscript was sent to Sir Joseph Banks, and it is now in the British Museum.

By the nineteenth century, American botanical ladies were as industrious as those of Europe. 'A love for Botanical Science is fast progressing in our happy country,' wrote Dr Baldwin of Wilmington in 1811: 'imperfect as my knowledge of Botany is, I am engaged in giving lectures, principally to young ladies, who are enamoured of the science.' In New York in 1826 'a bouquet in the possession of a belle attracted the notice of an inquisitive swain. She answered his queries by telling the ignorant fashionable the common names of the flowers accompanied with the generic and specific names according to the classes of Linnaeus. The beau was so humiliated and confounded, that he betook himself to the science, the better to qualify him for her company.'

This profusion of amateurs led inevitably to the emergence of the professional female draughtswoman. Indeed, this phenomenon had made its appearance quite early, like out-of-season swallows. The flower-plates in Ferrari's *Flora* of 1633 were done by a woman, Anna Variana; and nobody could be more practical and professional than Maria Sybilla Merian (1647–1717). Though primarily an entomologist, all her insects were portrayed upon plants; and few have gained greater mastery of a double field. Her Swiss father, Matthias Merian, was an engraver, living in Frankfurt; her Dutch mother the daughter of a still more famous engraver, Johann de Bry. Her father having died, her mother remarried; her stepfather was a German flower-painter called Marrell (himself a pupil of de Heem) and Maria in turn married one of his pupils, a German named Graaf. So she had every opportunity of becoming skilled in the drawing and engraving of flowers.

Two swallows, however, do not make a summer, and the professional lady flower-painter hardly developed before the late eighteenth century —often among the wives and daughters of nurserymen, who took this opportunity of helping in the family trade. A notable example was Anne Lee (1753–90), favourite daughter of James Lee, one of the founders of the famous firm of Lee and Kennedy. She was the pupil of Sydney Parkinson, a draughtsman who sailed with Captain Cook and died on the homeward voyage, bequeathing to her his painting-materials. Her exquisite drawings were so detailed and accurate that her father sent some of them to Linnaeus to help in the determination of new species. Most

of her work was done for private patrons, and none was published in her short lifetime.

Samuel Curtis (nephew of William), a nurseryman and florist, had four daughters, all of whom were said to excel in flower-painting, and one at least of whom contributed plates to the *Botanical Magazine*; but for his handsome folios, *The Beauties of Flora* (1806–20) and *A Monograph on the Genus Camellia* (1819), he enlisted the services of another professional lady, Clara Maria Pope. She was followed by Mrs Withers, a teacher of flower-painting and Botanical Painter to Queen Adelaide; by the prolific but elusive Miss Drake; and by a number of others who more or less earned their livings by their artistic talents.

The Artists

It is extraordinary, however, how little is known of the artists who supplied this vast demand for floral illustrations, especially those of nineteenth-century Britain. The French seem to have paid their artists more attention, and Robert, Aubriet, Monnoyer, Turpin, Redouté and others are relatively well documented. But these were the acknowledged masters of floral art, unrivalled except for van Spaendonck, Ehret and the Bauer brothers, also comparatively well known. Very little notice seems to have been taken of the British artists, few of whom even attained the distinction of a few lines in the *Dictionary of National Biography*. They had undistinguished names such as Smith, Cooke and Clark; to add to the confusion there were two Andrews, two Edwards, two William Hookers and a John Curtis, who was not related to William or Samuel Curtis, though he worked for the *Botanical Magazine*. It would take an army of genealogical researchers to disentangle them, and the scent has long grown cold. The little that is known or can be surmised about them is given in the Biographical Notes.

There are also books—and these some of the finest—in which the plates are anonymous, without so much as an initial to help in the identification of the artist. Others are signed by the engraver alone, with no indication as to whether or not he also did the drawings. (He may have been thought the more important of the two; the engravers of Robert's *Recueil des Plantes* [*c.* 1701] were paid four times as much as the draughtsmen.) It is fair in some cases to assume that the unsigned plates were drawn by the author, as several of the writers were also very fine artists. Colonna is

thought to have etched his own plates, and those of Reneaulme are also believed to have been his own work. John Hill did at least some of his own engraving, but he also employed others, more skilful than himself, whose work is unsigned. Of the known self-illustrators, John Curtis was superb, both as author, draughtsman and engraver; George Loddiges drew a large proportion of the plates for his *Botanical Cabinet*, and Dr W. J. Hooker did all his own drawings until pressure of other work obliged him to employ Walter Fitch. John Lindley also illustrated his first two books himself, though none of his later ones; and Dean Herbert, a most skilled botanist and horticulturist (as well as a clergyman, poet, politician and much else), was also an excellent draughtsman, who contributed many plates to the *Botanical Register* and *Botanical Magazine*.

A characteristic of nineteenth-century botanical illustration was the long and close association of one botanist with one draughtsman or engraver. (Eighteenth-century artists seem to have had patrons rather than partners.) One of the most remarkable of these partnerships was that of Walter Fitch with the Hookers, father and son; they worked together for forty-three years, and then parted owing to a dispute about pay. James Sowerby collaborated with Sir J. E. Smith for thirty-six years (and this says much for Sowerby). Sydenham Edwards illustrated the *Botanical Magazine* for twenty-seven years, sixteen of them after William Curtis's death. And there were lesser instances; Robert Sweet almost invariably employed E. D. Smith, and any book by Robert Tyas was sure to have plates by James Edwards. Works by John Lindley were predominantly, though not exclusively, illustrated by Miss Drake, and George Cooke was associated with the *Botanical Cabinet* for the whole of its twenty volumes. In none of these cases did author and artist work together for less than fifteen years. In France, Turpin and the botanist Poiteau (himself a good artist) were close friends and colleagues for some forty years, until parted by death.

The 119 plates in this book have been selected from more than 10,000 examples—and this, without examining more than a few random volumes of most of the periodicals. Some, of course, could be dismissed at a glance; but in many cases, the choice was hard to make. With one or two exceptions (for example, small woodcuts taken from large herbals) all are from books of octavo or small quarto size, and almost all are reproduced approximately the size of the originals.

Biographical Notes

———

FOUR FRENCH ARTISTS

ROBERT, NICOLAS (1614–85). Two artists were present in Nicolas Robert, just as later there was a double Redouté—a painter of pretty flowers and a scientific botanist. His early work was of the florilegium type—studies of ornamental flowers with no scientific pretensions; later it became more botanical, and if possible even more beautiful. The son of an innkeeper of Langres in Burgundy, nothing is known of his education except that it included a sojourn in Italy: his first book, *Fiori Diversi* (1640), was published in Rome. A year later he was in Paris and painting garden-flowers on vellum for the celebrated *Guirlande de Julie*, a manuscript anthology of pictures and specially written poetry presented to Julie d'Angennes, daughter of Mme de Rambouillet, by her lover the Duc de Montausier before his departure to the wars. Robert then entered the service of Gaston, Duke of Orleans, and was employed drawing new plants, and also birds and animals, at the Duke's château at Blois. It was after this that his work became more scientific, owing, it has been suggested, to the influence of the Scottish Robert Morison, then in charge of the Duke's botanic garden. Gaston died in 1660; Robert moved to Paris, and four years later was appointed 'Peintre Ordinaire à sa Majesté pour la Miniature'. He was the first to hold this office, and the Orleans series of 'velins' (drawings on vellum), purchased by Louis XIV, was the start of that royal collection, which, continued by other hands, accumulated steadily till 1905. By 1669 Robert had begun work on the illustrations for the grand History of Plants planned by the Académie des Sciences; a prospectus with thirty-eight of his plates was published in 1676 (in which year he also produced a book on birds) but the ambitious work never fully materialized, though 319 finished plates (not all by Robert) were published without text after his death. *(Plates 35, 36, 37)*

AUBRIET, CLAUDE (1665–1742). Aubriet was said to be the 'très digne disciple' of Robert, but it is unlikely that they actually met; Aubriet was only twenty when Robert died, and might not yet have come to Paris from his native Châlons-sur-Marne in Champagne. He became the pupil of Robert's successor, Joubert; and was chosen by J. P. de Tournefort, then King's Botanist, to illustrate his important *Elémens de la Botanique* (1694), his dissections being as essential as the text in the elucidation of Tournefort's new botanical system. When Tournefort made his celebrated voyage to the Levant in 1700–2 he took Aubriet with him as draughtsman and congenial travelling-companion; the artist worked

very hard, even to the detriment of his health, drawing landscapes, antiquities, birds, animals and local costumes as well as plants. This fruitful partnership might long have continued, but for the death of Tournefort as the result of a street-accident in 1708, shortly after Aubriet had succeeded his master Joubert as miniature-painter to the King. He shared a house in the Jardin des Plantes with the botanist Sebastien Vaillant, whose work also he illustrated. In 1719 he made another, though less adventurous, journey, this time to Spain, with Tournefort's successor, Antoine de Jussieu, and Antoine's brother Bernard. It was for the former that he prepared the series of drawings, some of which are reproduced here. De Candolle named the Aubrieta in his honour; and Bernard de Jussieu walked in the front row at his funeral. *(Plates 56, 57, 58, 59)*

REDOUTÉ, PIERRE-JOSEPH (1759–1840). Redouté is chiefly known for his great colour-plate books—*Les Liliacées, Le Jardin de la Malmaison,* and above all, *Les Roses*—but he also did a great deal of serious black-and-white work for serious botanists, in its own way just as fine. (Unlike Robert, his botanical work came first and the pretty pictures afterwards.) His father was a Belgian interior-decorator, and he earned his living from the age of thirteen as an itinerant house- and portrait-painter, till he came to Paris to join a brother who was a theatrical designer. He discovered the Jardin des Plantes as a place in which to draw flowers, and met there the painter van Spaendonck and the botanist L'Heritier. The latter trained him in botanical illustration, and took him on a momentous visit to England in 1787, where he is said to have learnt the art of stipple-engraving. In all the subsequent political upheavals in France Redouté rode the waves like a cork; throughout the Revolution, Commune, Empire and Restoration he always had some new friend or patron to help and support him when the old ones failed. He was official flower-painter in turn to Marie Antoinette, to the Empress Joséphine, to her successor the Empress Marie Louise, and to Queen Marie-Amélie. When van Spaendonck died, he succeeded to his position as Maître de Dessin at the Muséum d'Histoire Naturelle, and he numbered the highest (female) aristocracy among his pupils, but he retained throughout the simplicity and integrity of his character. His best work was done under the patronage of the Empress Joséphine.

Redouté's life was not entirely a success story; he spent as fast as he gained, his craft of stipple-engraving was superseded by the cheaper (and nastier) lithography, his work went out of fashion, and he died in comparative poverty.
 (Plates 83, 90, 91)

TURPIN, PIERRE JEAN FRANÇOIS (1775–1840). Turpin was the son of a poor artisan of Vire in Normandy, and received his drawing instruction at the local school. At fourteen he joined the hastily organized Revolutionary Army, and five years later was sent with his regiment to Haiti in the French West Indies, where the negroes were then in a state of insurrection. There he presently met

Pierre Antoine Poiteau (1766–1854), who was sent to the island in 1796 to collect for the Jardin des Plantes, and the two became lifelong friends; Turpin, it is said, taught Poiteau drawing and Poiteau taught Turpin botany. Nominally, Turpin remained in the army at least till 1803, but he seems to have had extraordinarily accommodating superiors who exacted few or no military duties. When he was recalled with the regiment to France he was employed by General Leclerc at Rennes as a draughtsman; then he was given leave to return to Haiti, where he rejoined Poiteau and spent nearly a year on the botanical exploration of the Ile de la Tortue, just off the north-west point of Haiti. Poiteau went to America at the end of 1800, but Turpin remained, making drawings for the American consul, Stevens. Several authorities repeat a statement that Turpin met Alexander Humboldt in America and returned with him to Europe in 1802; but in that year Humboldt was in Peru, and his brief sojourn in Pennsylvania and return to France did not take place till 1804. At any rate, Turpin rejoined Poiteau in Paris, and it was then that his career as a botanical illustrator really began. They collaborated in the production of a number of important books, and Turpin also worked independently for Humboldt and other botanists. The examples of his work reproduced here show him as a master of the miniature; but he was equally skilled on a large scale, and has been called the greatest natural genius of his time—not even excepting Redouté, who died in the same year.

(Plates 45, 46)

FOURTEEN BRITISH CRAFTSMEN

ANDREWS, HENRY CHARLES. The dates of birth and death of this artist, the founder of the *Botanist's Repository*, are unknown, and so is the date of his marriage to Anne Kennedy; he had been drawing plants at her father's nursery from the time when she was ten or twelve. His most important work was his serially published *Coloured Engravings of Heaths* (1794–1830), but he also produced *The Heathery*, a 'little brother' in six octavo volumes, and handsome works on geraniums and roses. His contemporaries were little impressed either by his flat, highly coloured drawings or by his botanical knowledge; the *Repository* was called 'a work where the author struggles, with considerable success, to compensate for the total absence of science'. *(Not represented)*

ANDREWS, JAMES (*c.* 1801–76), of Walworth, was apparently no relation of H. C. Andrews. Nothing is known of his early life: his first flower-drawings were published when he was about thirty-four. They were mostly of a sentimental sort—it could be said of them, as it was of the forget-me-not, that 'few better deserve the name of pretty'—but they had great delicacy and charm, which is more than could be said for the work of the other Andrews. His undated folio, *Flora's Gems or the Treasures of the Parterre* (twelve bouquets, with verses by Louisa Anne Twamley), was dedicated to Princess Victoria, hence before 1837.

His long association with the books of the Reverend Robert Tyas began in 1835, with his charming miniature *Sentiment of Flowers*, but his later work (Tyas's *Popular Flowers*, 1843 and his own *Choice Garden Flowers*, c. 1860) was hardly up to the same standard. *(Plate 118)*

CLARK, WILLIAM. A most meritorious but not prolific artist, of whom practically nothing is known. He was called 'draughtsman and engraver to the London Horticultural Society', but the work he did for them was scanty, and no records seem to have been kept. Robert Sweet called him the worst botanical artist in London, and said he was a protégé of John Lindley, who showed him drawings by E. D. Smith (q.v.) as models to follow; but most of us would agree with Lindley that his figures in Morris's *Flora Conspicua* are 'real specimens of art'. His only other works were the illustrations to Mrs Hey's *Moral of Flowers* and fifty-three of the 185 plates in Stephenson and Churchill's *Medical Botany*, mostly in the first volume. All four volumes are dated 1831 and no work by Clark later than this is known. *(Plates 69, 70, 96, 103, 104)*

COOKE, GEORGE (1781–1834). George Cooke, engraver, was born in London, the son of a wholesale confectioner of German origin. From about 1802 to 1833 he engraved an immense number of prints, mainly of topographical subjects, including the illustrations for Sir Walter Scott's *Provincial Antiquities and Picturesque Scenery of Scotland*; he probably regarded his work for Loddiges' *Botanical Cabinet* merely as light recreation. He engraved the whole of the two thousand plates, and drew 786 of them (George Loddiges himself drew 833)— so far as is known, Cooke's only botanical work. From 1824 to 1828 he took an increasing share in the work, but in 1829 his contribution to the drawings suddenly dropped to six plates, and for the remaining four volumes he did the engraving only. Loddiges terminated the publication in 1833, 'the precarious state of our draughtsman's health not permitting him to go on any farther'. Cooke died of brain-fever in February 1834. *(Plates 66, 93, 94)*

CURTIS, JOHN (1791–1862). John Curtis was born in Norwich, the son of a stone-engraver and sign-painter. He was almost from infancy an entomologist; but many botanists are also interested in entomology, and his work brought him into contact with J. E. Smith, the Hooker family and John Lindley—all of Norwich. It was natural, then, that after he came to London in 1817 and was in want of money, he turned to botanical drawing as a stopgap; he had studied copper-engraving for his entomological work, and was accustomed to drawing flowers. He contributed plates to the *Botanical Magazine* from 1819 to 1826, though we have the assurance of the grandson of the then owner, Samuel Curtis, that he was no relation of their family. He also worked for the Horticultural and Linnean Societies. In 1824 his great *British Entomology* began to appear—770 plates in sixteen volumes—in which each insect is shown with a more or less

appropriate plant. Some of the plants are rather small and scrappy, but they are exquisitely drawn and coloured, while the insects almost crawl off the page; Cuvier called this book 'the paragon of perfection'. After this, Curtis's work was entirely entomological, and so meticulous that at one time he reproached his engraver for putting only twelve hairs instead of thirteen on the tail of a fly. But for most of *British Entomology* Curtis was his own engraver, and his work, especially on the dissections of the insects, was so extremely fine that it is no surprise to learn that in the last year of his life he became totally blind. He died, loaded with entomological honours, in 1862. *(Plates 105, 106, 107)*

DRAKE, S. A. (MISS). It is disgraceful that nothing is known of this competent and prolific artist except the dates of her published work and the fact that she lived in the part of London called Turnham Green. Most of her work was done in association with John Lindley, also of Turnham Green; when the American botanist Asa Gray visited the Lindleys in 1839, he found Miss Drake there, quite at home, and thought she was related to Lindley's wife. From 1831 to 1847 Miss Drake illustrated the *Botanical Register*, of which Lindley was then editor; she provided plates for the Horticultural Society of which he was assistant secretary, and for two of his books. Almost the only work she did for others consisted of plates for Bateman's *Orchidaceae of Mexico and Guatemala* (and Lindley, too, was an orchid specialist) and a few in the last volume of Wallich's *Plantae Asiaticae Rariores*, the work in which Lindley named a plant 'Drakea' in her honour. Nothing is heard of her after 1847. In that year the *Botanical Register* ceased publication, and the *Transactions* of the Horticultural Society were discontinued in 1846, in favour of the less expensive Journal, which, however, still had plates by Miss Drake in its first volume. Did she cease work in 1847 because she no longer had any employment, or did Lindley give up the *Register* because she had died and he had no one to replace her? The complete absence of any later work makes the second solution seem likely. *(Plate 112)*

EDWARDS, JOHN. This artist is known only for his handsome but overpraised folio works, *The British Herbal* (1770; reprinted under a different title in 1775) and *A Collection of Flowers Drawn after Nature*, 1783–95. He was his own author, artist, etcher, colourist and publisher; like the pavement artists one used to see, who proudly claimed that their chalked monstrosities were 'all their own work'. He is mentioned here only to avoid possible confusion with the other Edwards who follows. *(Not represented)*

EDWARDS, SYDENHAM TEAST (1769?–1819). Sydenham Edwards and James Sowerby were the Heavenly Twins of British botanical illustration in the early nineteenth century. Both were eminently trustworthy artists, always competent though not always inspired. Edwards was the junior by twelve years, but they began botanical work within a year of each other. Edwards was the

less alarmingly prolific; he merely contributed over 1,700 plates to the *Botanical Magazine*—almost its entire quota over twenty-seven years—and some to the *Flora Londinensis*, illustrated the first four volumes of the *Botanical Register*, and supplied sixty plates to MacDonald's *Complete Dictionary of Practical Gardening*; these were not wholly a success, as plants grouped three or four on a page in alphabetical order rarely make harmonious companions. He also contributed some plates to Thornton's famous *Temple of Flora*. And that was about all, so far as plants were concerned; but just as Sowerby did much non-botanical work on shells and minerals, so Edwards produced a book of coloured engravings on British breeds of dogs.

He was the son of a schoolmaster and organist of Abergavenny in Monmouthshire. A Mr Denman saw some copies he had made of plates in the *Flora Londinensis*, and showed them to William Curtis, who was so impressed by the lad's talent that he had him brought to London and trained as a botanical artist; his first plate in the *Botanical Magazine* appeared in 1788 when he was about nineteen. He became Curtis's close companion on many botanical excursions, drawing birds and other objects of natural history as well as flowers. Sixteen years after Curtis's death he left the *Botanical Magazine* to found his own *Botanical Register*, but he only lived four years longer. *(Plates 64, 111)*

FITCH, WALTER HOOD (1817–1892). Fitch forces himself on our attention by his very ubiquity; his patron, W. J. Hooker, was a prolific author, but Fitch outdistanced him, as he worked for other botanists as well; he is estimated to have produced 9,960 published botanical drawings. An apprentice to a Glasgow firm of calico-printers, he came to Dr Hooker (who then held the chair of botany in that city) on his free evenings to help in the preparation of herbarium specimens; but his talent for drawing soon became apparent, and Hooker bought him out from the remainder of his apprenticeship and employed him, under his own tuition, as a full-time botanical artist. His first plate appeared in the *Botanical Magazine* in 1834, when he was only seventeen, and shortly afterwards he took over almost the whole burden of its illustration, which he carried for more than forty years. At first his drawings were engraved by Swan (q.v.) but by 1845 he had mastered the art of lithography, and from that date he lithographed his own drawings and often those of others. Meantime, he had moved with Hooker from Glasgow to Kew; and in 1847 he gave notice, because he thought he was underpaid. His salary was raised from £125 to £150 a year, and he continued to illustrate the works of the Hookers, father and son, and of a number of others, till 1877, twelve years after the elder Hooker's death. He then quarrelled with Sir Joseph Hooker—again over pay—and withdrew his services, together with a great pile of unused drawings, leaving the illustration of the *Botanical Magazine* to be carried on at a moment's notice by Hooker's daughter, Lady Thiselton-Dyer. Sir Joseph bore no malice, and persuaded Disraeli to grant Fitch a civil list pension of £100 a year, which he enjoyed till his death in 1892. *(Plate 117)*

HOOKER, WILLIAM (1779–1832). William Hooker of London was not related to Sir William Jackson Hooker (1785–1865) of Norwich and Kew, though they have sometimes been confused by those who should know better. He was a pupil of Francis Bauer, and we first hear of him as the draughtsman of R. A. Salisbury's *Paradisus Londinensis* (1806–8). Indeed, this seems to have been largely Hooker's project; Salisbury referred to him as 'the able artist who planned and executed' the work, and said it was discontinued (after 117 plates) when Hooker was appointed official artist to the Horticultural Society. From then on, he specialized chiefly in the portrayal of fruit, and in 1814 the Fruit Committee commissioned him to do a series of drawings—twenty complete and twenty incomplete a year—some of which were reproduced in the Society's *Transactions*. Ill health made it difficult for Hooker to produce his full quota, but he achieved 158 drawings by 1821, besides five or six of the illuminated pages prepared by the Society for the signatures of royal patrons, and his own fine *Pomona Londinensis* (1813–18). No work is recorded between 1821 and his death— nine years before the other Hooker came from Glasgow to London. He is commemorated in the pigment Hooker's Green, which seems to have been his invention. *(Plate 92)*

NODDER, FREDERICK POLYDORE (d. *c.* 1800). As a plant-draughtsman Nodder was not very distinguished, though he styles himself 'Botanical Artist to Her Majesty'—at that time Queen Charlotte, not Caroline, as has been erroneously stated. About 1772 he was employed by Sir Joseph Banks to make finished drawings from the sketches and herbarium specimens of Sydney Parkinson, who died on the way home from Captain Cook's first voyage, and to engrave them for a publication that never materialized. Some of these plates have survived, but the engraving is open and coarse, with much cross-hatching, which gives the leaves the texture of cloth. Far better were the delicate drawings made by Nodder for Thomas Martyn's four-volume *Flora Rustica*, on the plants and weeds of agriculture. He also illustrated the same author's botanical *Thirty-Eight Plates* (a simple solution to the problem of choosing a title!) and supplied a few pictures for Darwin's *Botanic Garden*. But on the whole the Queen seems to have made a poor bargain. *(Plates 49, 71)*

SMITH, EDWIN DALTON (b. 1800). Smith began life as a fruit- and flower-painter, and first exhibited at the Royal Academy when he was only sixteen. He started botanical work with the plates for Robert Sweet's *Geraniaceae*, begun in 1820; and thereafter he worked principally for Sweet, though he also contributed to Watson's *Dendrologia* (1825), Mackintosh's *Flora and Pomona*, and the first six volumes of Maund's *Botanic Garden* (1825–36). He seems chiefly to have been known as a portrait-miniaturist; among his sitters were the dancers Taglioni, Fanny Elssler and Fanny Cerrito, and his portraits of the two latter were engraved for Giraldon's *Les Beautés de L'Opéra*—the sort of pin-ups that would have been

appreciated by Mr Guppy in Dickens's *Bleak House*. Smith was elected F.L.S. in 1823, but apparently did no further botanical work after 1836, though he continued to paint miniatures till 1852. His skill on a small scale is shown in the originals for his plates to Maund's *Botanic Garden*—brilliant jewels $2\frac{1}{2} \times 2$ inches square *(Plates 98, 99, 100, 101)*

SOWERBY, JAMES (1757–1822). Sowerby was not from the start a botanical artist; he was thirty years old before he found his true vocation. A student at the Royal Academy, he was apprenticed first to a marine artist, and then worked as a drawing-master and portrait-painter. In 1788 he published *An Easy Introduction to Drawing Flowers*, having then been producing plant-pictures for just three years; the first plate in the *Botanical Magazine* (1787), though unsigned, is known to have been by him. It is an indication of his quality that he was distinguished by L'Heritier and employed to produce some of the plates in that author's *Sertum Anglicum* (1784–5) and *Geraniologia* (1787)—L'Heritier, who had just discovered and brought forward the previously unknown Redouté.

In 1790 appeared the first volume of *English Botany*, which was to continue for twenty-four years and run to nearly 2,600 plates. It was entirely Sowerby's project; the text of the first three volumes was gratuitously contributed by Dr George Shaw and others, and it was not until the fourth that the name of Dr (later Sir) J. E. Smith appeared—and then only because Sowerby paid him a guinea a time to supply the botanical descriptions. (Later Smith took all the credit, and did not like people to refer in his hearing to 'Sowerby's *Botany*'.) Nevertheless, Sowerby illustrated all Smith's books—five of them, between 1789 and 1805—besides his own handsome folio *Flora Luxurians* (1789–91), a work on florist's flowers that never got beyond the first three numbers.

This was only a fraction of this incredible artist's work. Concurrently with *English Botany*, he was producing his *Coloured Figures of English Fungi*, with 440 plates, which was followed by works on fossil minerals, shells and zoology. He also found time to marry and raise a family; two of his three sons, two of his four grandsons, and great-grandson become natural-history draughtsmen. Smith named a genus 'Sowerbaea' in his honour, and he is also commemorated in a whale, *Mesoplodon sowerbiensis*. *(Plates 84, 85, 86, 87, 88)*

SWAN, JOSEPH (d. 1872). Within a year or two of his arrival in Glasgow, Dr W. J. Hooker made the acquaintance of Joseph Swan, then newly established as an engraver and copperplate printer in Glasgow's Trongate, and beginning to make a name for his local topographical views. Hooker at that time was illustrating his own books, and Swan engraved his drawings from 1823, and the plates in the *Botanical Magazine* from 1827—seven years before Hooker's discovery of Walter Fitch. (There have been many engravers; but Swan's work was brilliant and characteristic.) When Hooker was appointed Director of Kew Gardens in 1841 and went south, taking Fitch with him, Swan did not accompany them;

he was probably unable to leave a wife and a flourishing business, which at one time included the engraving of bank-notes. But he continued to engrave the plates for the *Botanical Magazine* till it changed over to reproduction by lithography in 1845. His firm produced a series of popular writing-books for schools— 'Swan's Universal Copy Books'—so it is interesting to note a distinctly calligraphic quality in some of his engravings, such as the Mutisia reproduced here.

(Plate 110)

Bibliography

*Plate numbers are given in brackets
at the end of each entry*

———

PRINTED BOOKS

ANONYMOUS: *The Compleat Florist*, 1747 (47)

ABBOTT, C.: *Flora Bedfordiensis*, 1798 (89)

ALECHAMPS, J. D': *Historia Generalis Plantarum*, 2 vols, 1586–7 (19)

BAXTER, W.: *British Phaenogamous Botany*, 6 vols, 1834–43 (114, 115)

BELON, P.: *De Arboribus Coniferis*, 1553 (13)

BIGELOW, J.: *American Medical Botany*, 3 vols, 1817–20 (63, 76)

BOCK, J.: *De Stirpium Historia*, 1552 edn (3, 6, 12)

BRADLEY, R.: *A History of Succulent Plants*, 1716–27 (41)

CHAUMETON, F. P., CHAMBERET, J. B., and POIRET, J. L. M.: *Flore Médicale*,
 8 vols, 1814–20 (45)

CLUSIUS (C. DE L'ECLUSE): *Rariorum Aliquot Stirpium per Hispanias Observatarum
 Historia*, 1576 (17)

COLUMNA (COLONNA, F.): *Phytobasanos sive Plantarum Aliquot Historia*, 1592 (21)

—— *Ecphrasis: Minus Cognitarum Stirpium Aliquot . . .* 1606–16 (22)

CURTIS, J.: *British Entomology*, 16 vols, 1823–40 (105, 106, 107)

CURTIS, W.: *Abridgement to the Flora Londinensis*, 1792–3 (81, 82)

DESFONTAINES, R.: *Flora Atlantica*, 4 vols, 1799–1800 (83)

DODOENS, R.: *Florum et Coronarium Odoratarumque . . . Historia,* 1569 (14, 18)

FERRARI, G. B.: *Flora seu de Florum Cultura*, 2nd edn, 1638 (27, 28)

FRANEAU, J.: *Le Jardin d'Hyver ou Cabinet de Fleurs*, 1616 (23, 26)

FRÉZIER, A. F.: *A Voyage to the South Sea . . .,* 1717 (53)

FUCHS, L.: *Labliche Abbildung und Contrafaytung aller Kreuter*, 1545 (4)

FURBER, R.: *The Flower Garden Display'd*, 1734 (39, 40)

GILIBERT, J. E.: *Exercita Phytologica*, 2 vols, 1792 (30, 31)

—— *Démonstrations Elémentaires de la Botanique*, 4 vols, 4th edn, 1796 (29)

GRAY, A., and SPRAGUE, I.: *The Genera of the Plants of the United States*,
 2 vols, 1848 (116)

HELWING, G. A.: *Flora Campana seu Pulsatilla*, 1719 (54, 55)

Herbarius, The German (Herbarius zu Teutsch), 1485 (5, 8, 11)

—— *The Latin (Herbarius moguntinus)*, 1484 (2)

HEY, MRS M.: *The Moral of Flowers*, 1835 (96)

HILL, J.: *Hortus Kewensis*, 1769 (77, 78, 79)

KAEMPFER, E.: *Amoenitates Exoticarum*, Part V, 1712 (33, 34)

KNIPHOF, J. H.: *Herbarium Vivum*, 12 vols, 1761– (60)

LAUREMBERG, P.: *Apparatus Plantarius Primus*, 1632 (38)

LEHMANN, J. G. C.: *Monographia Generis Primularum*, 1817 (95)

LE MOYNE DES MORGUES, J.: *La Clef des Champs*, 1586 (10)

LIGHTFOOT, J.: *Flora Scotica*, 2 vols, 1777 (80)

LONITZER, A.: *Kreuterbuch*, 1582 edn (7)

MARTYN, T.: *Flora Rustica*, 4 vols, 1792–4 (49, 71)

MERIAN, M. S.: *Erucarum Ortus, Alimentum et Paradoxa Metamorphosis*, 1717 (50, 51, 52)

MICHAUX, A.: *Flora Boreali Americana*, 2 vols, 1803 (90, 91)

MORRIS, R.: *Flora Conspicua*, 1825 (69, 70, 104)

PICCIOLI, A.: *L'Antrotrofia ossia la Coltivazione de' Fiori*, 2 vols, 1834 (108, 109)

POMET, P.: *A Compleat History of Druggs*, 2 vols, 1712 (32)

PURSH, F.: *Flora Americae Septentrionalis*, 2 vols, 1814 (92)

RENEAULME, P.: *Specimen Historiae Plantarum*, 1611 (24, 25)

ROBERT, N.: *Variae ac Multiformes Florum*, n.d. (35, 36)

——— *Diverses Fleurs*, n.d. (37)

SAINT-HILAIRE, J.: *Plantes de la France*, 10 vols, 1805–22 (72, 73)

SAYERS, R., and others: *The Florist*, c.1760 (62, 65, 68)

SMITH, J. E.: *Plantarum Icones Hactenus Ineditae*, 1789–91 (84)

SOWERBY, J.: *English Botany*, 36 vols, 1790–1814 (48, 86, 87, 88)

STEPHENSON, J., and CHURCHILL, J. M.: *Medical Botany*, 4 vols, 1831 (103)

SWEET, R.: *The Cistinae*, 1825–30 (98)

——— *Flora Australasica*, 1827–8 (100, 101)

THURNEISSERUS, L.: *Historia sive Descriptiones Plantarum*, 1578 (20)

TRATTINNICK, L.: *Neu Arten von Pelargonien*, 5 vols, 1825–31 (67)

TWAMLEY, L.: *The Romance of Nature, or the Flower-Seasons Illustrated*, 2nd edn, 1836 (113)

TYAS, R.: *Popular Flowers*, 1843 (118)

WALCOTT, J.: *Flora Britannica Indigena*, 1778 (44)

ZORN, J.: *Icones Plantarum Medicinalium*, 6 vols, 1779–84 (43)

——— *Dreyhundert Auserlesene Americanische Gewächse*, 3 vols, 1785–8 (74)

PERIODICALS

The Botanic Garden, 1825–51 (99)

The Botanical Cabinet, 1818–33 (66, 93, 94)

The Botanical Magazine, 1787-present (85, 117)

The Botanical Miscellany, 1829–33 (110)

The Botanical Register, 1815–47 (64, 97, 111, 112)

MANUSCRIPTS AND ORIGINAL DRAWINGS

ANONYMOUS: Album of Chinese drawings, c. 1800. Royal Horticultural Society (61)

AUBRIET, C.: Collection of pen-and-wash drawings (before 1742). Royal Horticultural Society. (56, 57, 58, 59)

BADIANUS, J., and DE LA CRUZ, M.: *The Badianus Manuscript, c.* 1552. The Vatican Library, Rome. (15,16)

BARTRAM, W.: Natural History Drawings, 1756–88. British Museum (Natural History). (75)

DIOSCORIDES (= DIOSKURIDES, P.): *Codex Vindobonensis,* or the *Juliana Codex, c.*A.D. 512. National Library, Vienna. (1)

HERBERT, W.: Collection of watercolour drawings (before 1847). Royal Horticultural Society. (102)

LEE, ANNE: Watercolour drawings of Mesembryanthemums, 1777–9. British Museum (Natural History). (42)

LE MOYNE DES MORGUES, J.: Album of watercolour drawings, *c.* 1570 Victoria and Albert Museum. (9)

TURPIN, P. J. F.: Album of 25 watercolour drawings on vellum (before 1840). Royal Horticultural Society. (46)

The Plates

1. Asphodel *(Asphodelus microcarpus?)*

FROM THE *Codex Vindobonensis Dioscorides*, c. A.D. 512

With lamentable inconsistency our first plate, reduced in size, is taken from a flower-book that is by no means small; but this may perhaps be permitted on account of its great antiquity. The 'Juliana Codex' was made about A.D. 512 for the Christian princess Anicia Juliana, daughter of one of the Byzantine Emperors; it is the oldest surviving manuscript of the *Materia Medica* of the Greek physician Dioskurides or Dioscorides, and the earliest illustrated herbal. Its two large volumes contain 387 full-page plant-drawings on vellum, some possibly copied from sources going back to the time of the author in the first century. The drawing of the asphodel is remarkably subtle for so early a date, and the colours as fresh as when they were first painted.

One could hardly hope to have a more authentic picture of the flower reputed from the time of Homer to grow in the Elysian fields. Greece has prettier and more useful plants, but none more celebrated, especially by poets, most of whom probably had never seen the flower. It used to be planted round graves, for the practical reason that the edible roots were believed to nourish the spirits of the dead; but they are unpalatable unless cooked . . .

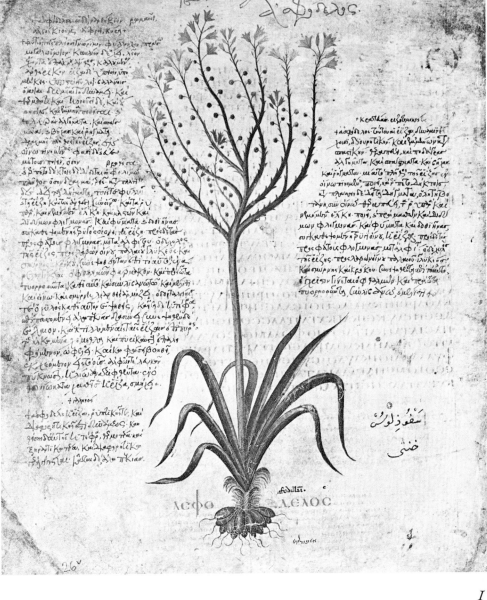

ασφοδελος

ασφο δελος

afodilla.

I

2. Lily *(Lilium candidum)*
FROM *The Latin Herbarius*, 1484

Except for that of Apuleius Platonicus in 1481, this small book was the first printed herbal; it was published anonymously in Mainz and is known for convenience as 'The Latin Herbarius'. The text deals chiefly with the medical uses of the plants, and the illustrations are usually quite recognizable, if one is so fortunate as to know the plants beforehand.

The lily has always been regarded as the epitome of whiteness and purity; though red, orange and yellow lilies also grow in Europe, in places more accessible than the wild station of *L. candidum* in the Balkans. The white lily, however, has been cultivated from time immemorial—it was known to the Cretans between 1750 and 1600 B.C.—partly at least as an ornamental plant, though the bulb was put to various prosaic medicinal uses.

3. Wild Strawberry *(Fragaria vesca)*
FROM *De Stirpium Historia*, BY J. BOCK, 1552 EDN.

Purchasers of herbals in the sixteenth century were expected, even encouraged, to paint their own copies, and several examples with contemporary colouring have survived. But the resources of the colourists were extremely limited; their brushes were clumsy, their pigments few and poor. These simple means, however, were adequate for a subject such as the wild strawberry, which always lends itself well to decorative design.

The 'excellent cordial smell' of dying strawberry-leaves mentioned by Bacon must have been produced by this species or by the hautbois strawberry *(F. moschata)* as no others were then grown. Lady Ludlow, in Mrs Gaskell's novel of that name (1856), was convinced that the elusive violet-like perfume was only perceptible to members of the aristocracy. A fine nose might now detect a faint odour of dying strawberry-leaves among the coroneted heads themselves.

4. Tansy *(Tanacetum vulgare)*
FROM *Labliche Abbildung und Contrafaytung aller Kreuter*, BY L. FUCHS 1545

Leonhardt Fuchs is known chiefly for his handsome *De Historia Stirpium* (1542), a much-copied landmark in the history of the herbals; it later reappeared in several smaller editions, from one of which our illustration is taken. Fuchs (the namesake of the fuchsia, which he never saw) was a renowned and beloved professor of medicine at the Protestant university of Tübingen.

Tansy *(Tanacetum vulgare)*, a handsome though somewhat coarse native plant, used to be grown in every cottage garden. It was a very old custom to eat tansy-puddings (made with the leaves) on Easter Sunday, 'to drive away the wyndenes yt they have gotten all the lent before, with eating of fish, peason, beanes and diverse kindes of wynde makyng herbes'. The Northamptonshire poet John Clare (1793–1864) described how as a child he 'tried through the pales to reach the tempting flowers' in other people's gardens, which included '. . . tansy running high'.

Lilium ⟨ lelien

Liliū eſt calidum z hūidum in pzimo z eſt comeſtiū
cum albis floribus: valet ad apoſtemata frigida ma/
turanda cum auxugia z oleo tritū z coctum z ſupz/
ponatur · Item radix lilij cum radice brance vrſine et
radice altee mutuo coce cum vino z coletur z colatue
addatur cera z oleū añ q̃ ſufficit z fiat vngentum cō
tra vitiū ſplenis z duritiē eius· Et radix lilij comeſt

*vinum decoctionis rad. lilij, eunti enbitij abſorg
noxios humores cunctos e corpore euacuat.
folia vero lilij in aceto cocta trita et
vulnera conglutinant·
Radix aſſata Et cum melle miſta impoſita ne
mollifie· et diſſectos pſanat*

2

Fragaria.
Erdbeer.

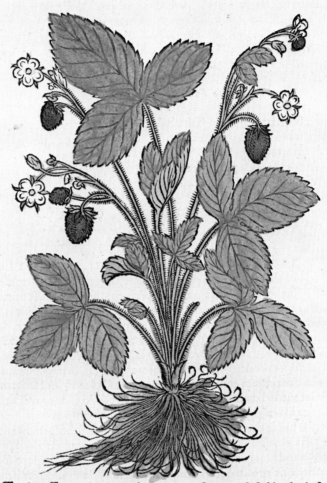

3.
 Tertium Fragariæ genus superiori coſinmile eſt, ſed herba hiſpidior,
Fraga partim ru utrinq; cineracei coloris. Fructum gerit partim rubrum, partim candidum,
bra, partim can- guſtu dulcem, odore gratiſſimum. Naſcitur in aridioribus & graminoſis
dida. agrorum limitibus, necnon & dumetis. Alia

3

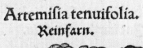

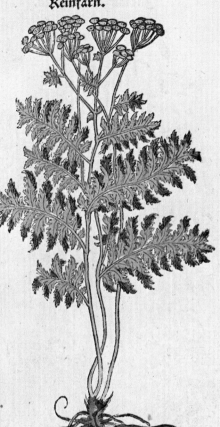

Artemisia tenuifolia.
Reinfarn.

27

Daneda.
Tanaceto

4

5. Onions and Garlic *(Allium* sp.*)*
FROM THE *Herbarius zu Teutsch*, 1485

The 'German Herbarius' or *Herbarius zu Teutsch* was larger and more handsome than the little 'Latin Herbarius' that preceded it by so short a time; it was also rather more wide-ranging in its choice of plants, and not so strictly confined to medical utility. Some, though not all, of its woodcuts are remarkably lively and naturalistic.

In a herbal alphabetically arranged, alliums naturally take pride of place, which they deserve for their useful culinary and medicinal properties. Onions and garlic were known from very early times to be valuable antiseptics, and it was facetiously suggested that in time of plague a ship freighted with peeled onions should be sent down the Thames, to purify the air and carry the infection out to sea. The smell of garlic, described by Fuller as 'somewhat valiant and offensive, but wholesome', was believed, understandably, to keep away vampires and witches. Competitors in races were advised to chew it, and it was fastened to the bits of racehorses, in the belief that none would then be able to pass them.

6. Carnation, Gillyflower *(Dianthus caryophyllus)*
FROM *De Stirpium Historia*, BY J. BOCK, 1552 EDN.

The carnation is one of the oldest of cultivated flowers, and is mentioned by Chaucer. Bock's picture shows with what care it was grown; and similar pots, carefully staked with a series of hoops to support the plants, are to be seen in many old paintings. 'Oh what sweete and goodly Gely floures are here', wrote Barnabe Googe in 1577: 'you may truely say that Solomon in all his princely pompe was never able to attayne to this beautie.' The flowers were valued also for their medicinal properties; among other things they would 'kepe the mind and spirituall parts from terable and fearfull dreames through their heavenly savour and moste sweete pleasant odour'.

7. Three Nettles *(Urtica urens, U. dioica* and *U. pilulifera)*
FROM *Kreuterbuch*, BY A. LONITZER, 1582 EDN.

Adam Lonitzer's very popular herbal, first published in 1555, contained little original matter, being largely derived from earlier sources. This was perhaps why Plumier named after its author the honeysuckle ('Lonicera'), which cannot stand alone but depends on the support of others.

Nettles are said to require no description: 'they may be found by feeling, on the darkest night.' And even at so early a date the three European species were clearly distinguished—the annual nettle, the perennial nettle, and the virulent Roman nettle, which, the story goes, was brought to England by the legions because they had been warned that 'the climate of *Brittaine* was so extreame cold, that it was not to be endured without some friction or rubbing, to warme their bloods, and to stirre up naturall heat . . .' Urtication, or rubbing with nettles, continued to be a recognized treatment for rheumatism and other ailments right up to the present century.

Alliũ knoblauch Capitulũ·iiij·

 Allium latine·ſtordon vel ſtordeon grece·Thaum arabice·

Garyophyllea:
Graßblům.

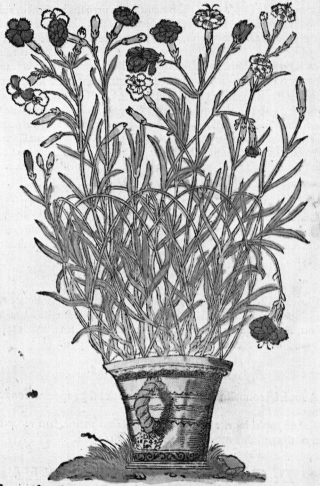

Rursus quædam simplici foliorum in floribus ordine contenta est, alia mul
tiplici prædita. Iam uix in omni genere stirpium ullam exisere arbitror,
quæ tanta colorum uarietate flores suos commendet, atq̃ altilis Garyo-
phyllea.

6

Groß brennend Nessel. Vrtica minor. Römisch Nessel.
 Eyternessel. Welsch Nessel. C

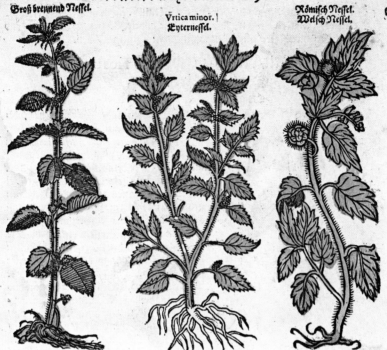

Zum vierdten ist der Binßauge/ welcher bey den Griechen heißt γαλιοψις, vnnd Plinio D
Vrtica, Labeo, Galiopsis, Ital. Ortica fetita. Gall. Ortie morte. Hiß. Vrtica muerta. Wirt Binß-
auge genennet/ dieweil die Bynen die Blümlin/ welche zum theil weiß/ vnnd zum theil
braun/ vnd rot/ vnd geel/ rings vmb den Stengel her wachsen/ suchen vnd daran saugen.
Die Blümlin dieser Nesseln nennet man Heubeln/ von der gestalt eines Heublins.

Weiter seind die todte Nesseln vnd taub Nesseln/ Vrtica mortua Latinis.

Zuletzt ist auch ein wildes Geschlecht/ so man nennet Waldnessel. Seind alle wol zu
kennen.

¶ Krafft vnd wirckung.

Nessel vnd ir Samen seind heiß im anfang deß ersten Grads/ vnd trucken im andern.
Seind vilerley Art.

Der Samen ist bräuchlicher dann das Kraut/ Sol von den Welschen Nesseln einge-
samlet werden/ so man in Gärten zielet.

Dieses Krauts Bletter vnd Samen braucht man in der Artzney/ das durchtringt von
Natur die feuchtigkeit deß Menschen/ vnd sonderlich mit schwitzen.

Lendenstein. Nesselnsamen ist gut fürn Stein/ sonderlich in Lenden.

Husten. Nesselnsamen gepüluert/ vnd getruncken mit Wein/ vertreibt den Stein in Lenden.

Nesseln mit wein gesotten/ vnd darüber getruncken/ vertreibt den Husten.

Grindt. Die Haut damit gewäschen/ heylet den bösen Grindt.

Den Samen gestossen/ gemischt mit Honig/ vnd also genützt mit wein/ benimpt den
alten Husten/ vnd raumet die Brust.

Die wurzel von grossen brennenden Nesseln mit Wein vnnd Honig gesotten/ alle
morgen vnd abendt drey oder vier Löffel voll warm getruncken/ vnnd gegurgelt/ vertreibe
Lungenprosten. den kalten Husten/ Keichen/ vnd ist gut zur erkalten Lungen.

Nesselblet

7

8. Paeony *(Paeonia mas)*

This is the 'male paeony' of Europe (the 'female' was *P. officinalis*), which was named by the Greeks after Paean, god of healing, and which was surrounded by almost as many superstitions as the mandrake itself. It had to be dug up at night, lest woodpeckers should peck out one's eyes; and like the mandrake, the groan it gave on leaving the ground was fatal to all hearers. The seeds were a protection against witchcraft, and the roots, even if only hung round the neck, a remedy for the falling sickness—though they look in the picture more likely to cause than to cure epilepsy. The seeds are slightly phosphorescent, whereby, Gerard says in his *Herball* (1597), 'plentie of it is in the night season found out and gathered by the Shepherds.'

9. Heartsease, Wild Pansy *(Viola tricolor)*
ORIGINAL DRAWING BY J. LE MOYNE DES MORGUES, *c.* 1570

By a clever piece of bibliographical detection, an album of drawings by an unknown hand in the Victoria and Albert Museum was identified as the work of Jacques le Moyne des Morgues, a Protestant of good family, who is believed to have fled to England after the Massacre of St Bartholomew in 1572, and who settled in Blackfriars under the patronage of Sir Walter Raleigh.

This was not his first visit to Britain. He had accompanied Admiral de Landonnière's ill-fated expedition to Florida as draughtsman and cartographer, and was one of the few to escape alive when the French settlement of Fort Caroline was sacked by the Spaniards in September 1565. The ship in which the survivors returned to Europe was blown out of course and landed at Swansea; de Landonnière went back to France, but de Morgues's subsequent movements are not certainly known.

At any rate, he had need of all the heartsease that England could provide, and his delicately painted florilegium shows his love for the simplest and most innocent of flowers—clover, double daisy, wild strawberry, wild rose. The heartsease is said to have sixty English names—including Shakespeare's 'Love in Idleness'.

10. Four Flowers *(Calendula, Matthiola, Rosa* and *Iris)*
TWO PAGES FROM *La Clef des Champs*, BY J. LE MOYNE DES MORGUES, 1586

This very rare little book by des Morgues is completely different in style from the contemporary herbals, because its purpose was different. It was intended to provide designs for embroidery, tapestry, goldsmith-work and other crafts; and it was dedicated in admiring and affectionate terms to 'Ma-dame de Sidney'—Lady Mary, mother of Sir Philip Sidney. The flowers need no explanation, except perhaps for the 'Stoke Ielivers', under which one might not perhaps recognize the common stock. The stock-gillyflower and the wall-gillyflower or wallflower were so named because of the resemblance of their scent to that of the clove-gillyflower or carnation; just as to the Greeks the stock and the wallflower were 'Violets'.

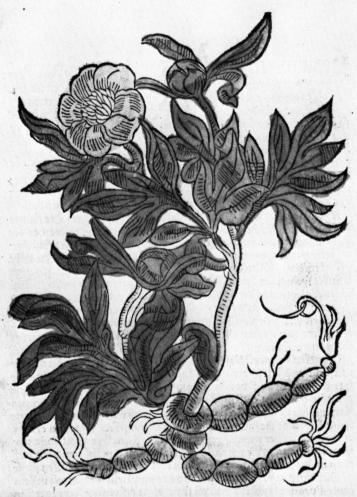

Pionia benonien korner oder bene dicten korner Capitulum·ccxcviij·

Jonia latine·arabice pynufer· Die meifter fprechen ge
meynglich das der ftam dar vff differ fame wachs habe groß
blůmen die fynt roit vnd fynt gemenglich genāt benedicten
rofen· Differ ftam ift vns wole bekant der wurtzeln dogent ift vns
befchriben in dē capitel pionia· Platearius fpricht das diß korner

9

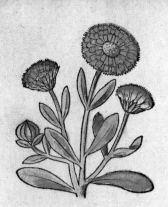

Latinè CALTHA.
Gallicè SOVCY.
Anglicè MARIGOLD.

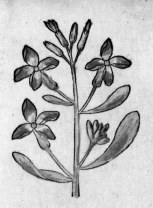

Latinè LEVCOIVM.
Gallicé IEROFLEE.
Anglicé STOKE IELIVERS.

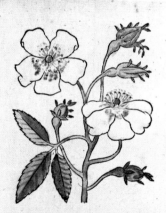

Lat.
Gall. ROSE MVSCADE.
Angl. MVSKE ROSE.

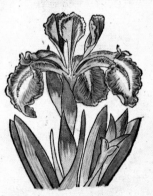

Lat. IRIS.
Gal. FLEVR DE FLAMBE
Ang. FLOWER DE LVCE.

11. Lesser Periwinkle *(Vinca minor)*
FROM THE *Herbarius zu Teutsch*, 1485

The coldly beautiful periwinkle has astringent properties, and was taken to be binding in every sense. 'The leaves of the lesser periwinkle,' wrote Culpeper, 'if eaten by man and wife together, will cause love between them.' It was useful, too, to stanch nosebleed. In Elizabethan times bands of periwinkle were tied round the calf of the leg to prevent cramp; but three centuries later, according to the enlightened Fernie (1895), one used instead 'a garter of small new corks strung on worsted'. The text above the picture refers to the plant on the previous page.

12. Cherry-Tree *(Prunus avium)*
FROM *De Stirpium Historia*, BY J. BOCK, 1552 EDN.

The herbal of Jerome Bock—also known as Hieronymus Tragus, 'Bock' and 'Tragus' both meaning a goat—was one of the earliest and most original. The author had a talent for plant-description, and his illustrator, David Kandel, had a sense of humour, and embellished many of his woodcuts with appropriate figures and animals.

Before the introduction of imported fruit, the cherry was more valued than it is now; it was grown to an extent that must have been a delight to the eye, and with an abundance that apparently made the depredations of birds negligible, since these are rarely mentioned. The cultivated cherry was brought to Rome by Lucullus in 89 B.C. from the town of Kerasous or Cerasus, now Karasu, at the south-west end of the Black Sea and is believed to have been introduced to Britain by the Romans. But the name Cerasus, which formerly covered all cherries, is now limited botanically to the morello or sour cherry, *Prunus cerasus.*

13. Larch *(Larix europaea)*
FROM *De Arboribus Coniferis*, BY P. BELON, 1553

I believe this book to be the first printed monograph or treatise on a single group of plants; its eight woodcuts, though much stylized, admirably convey the differences in growth of the various coniferous trees. Pierre Belon travelled widely under the patronage of the Cardinal de Touron, and wrote several books, mostly on natural history subjects; but trees were his first interest. He survived a perilous three-year journey in the Near East, only to be murdered by robbers in the Bois de Boulogne.

The larch is not a native of Britain, but has long been cultivated here. An eighteenth-century Duke of Atholl is said to have established it in the most difficult parts of his mountainous estate by firing its seed from a cannon, in canisters which broke and scattered on impact. Doubtless it was agreeable to see his barren crags clothed with trees, especially in spring, when 'green spray showers lightly down the cascades of the larch', but if the spots were too inaccessible for ordinary planting, it would also be impossible to make any use of the timber. Wordsworth hated this tree, and is said to have flung his hat at some seedlings of it.

sunderlichen Diascorides vnd spricht daz disses baums bletter vnd
samen vil dogent in yne haben. vnd synt keyß vñ feuchter natuer.
℟ Serapion Der safft von dissen blettern stopffet die fluß oder vß
genge der vigen kynde ℟ Den samen in gedrucken mit fenchel was/
ser machet lüfftig vmb die brust vñ benympt den büsten. ℟ Das
öle von dissem samen vñ bletter gemacht vñ das antzlitz do mit ge/
strichen benympt die geschwern vñ hitzigen blatern vnd macht das
antzlitz schön vnd glat ℟ Diser same meret die natur deß menschen
sperma genant vñ brenget lost man vnd frauwen das gedruncken
mit wyn. ℟ Von der baum wollen synden ich nit meen wan das die
frauwen schleyer vnd reyn düchlyn dar vß spynnen.

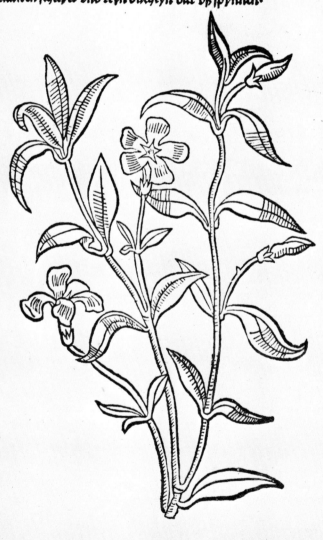

De Ceraso, Cap. XXXVIII.

Kirßbaum.

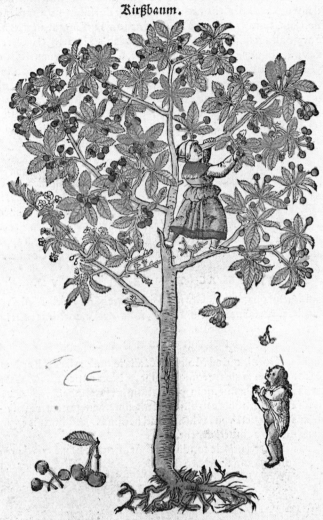

1.
Cerasus satiua. A

THENAEVS MEMORIAE PRODIDIT, LVCVLLVM
Romanorum Imperatorem, posteaq̃ debellato Mithridate ui-
ctoria

„ *& perfusa resina. Larix vstis radicibus non repullulat, Picea repullulat.*
Hactenus Plinius, qui cum multa de Larice dicat, ea ex Theophrasto ha-
bet, quæ prorsus Pino aut Piceæ debentur. Item cap.39. lib. 15. etiam scribit.
„ *Sic certè, inquit, Tyberius Cæsar concremato ponte naumachiario Larices ad*

Laricis figura.

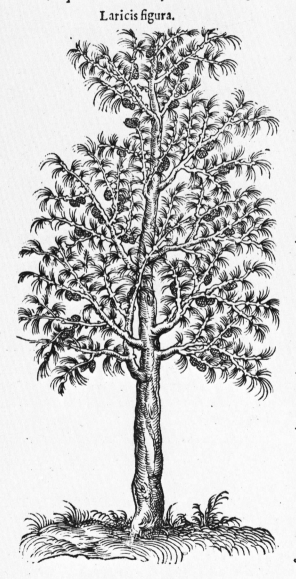

restituendum cædi ex
Rhetia præfiniuit.
Quanquam multa de
Larice apud Theo-
phrastum quemadmo-
dum lib.6.cap.24. le-
gantur hoc modo: De
cacuminationis demu-
tilationisque ratio in
paucis cogitanda est.
Pauca enim sunt quæ
emori ea de causa pos-
sunt, quippe decacu-
minatione. Abies Pi-
nus, Larix & palma
dumtaxat pereunt. Ista
tamen Larici non de-
bentur. Latinus enim
caudex à Gaza couer-
sus Laricem quidē ha-
bet, sed ex voce πεύκη
redditam. Theophra-
stus autem Pythios no-
mine nusquam Laricē
comprehendit, imò de
Larice mentio nunquã
apud eum reperitur.
Superest vt de Aga-
rico, id est Laricis fun-
go aliquid dicamus.

14. Snapdragon (*Antirrhinum majus*)

FROM *Florum et Coronarium Odoratarumque* . . ., BY R. DODOENS, 1569

Rembert Dodoens was one of the most important Flemish herbalists; but besides his major works he produced three or four little books, including this one, which treats of a selection of ornamental cultivated plants, though their uses and medical properties are still listed, as in the larger herbals.

His snapdragon seems to have altered little in four centuries, and might almost represent a modern bedding variety. Actually the flower has in the interval undergone many changes; at one time striped, mottled or bi-coloured, at another cultivated to a size of seven feet high and five across, before returning to a form which, except in size of bloom and variety of colour, is not far from the wild original. If the sides of the flower are gently pinched, it will gape and bite at us, as of old.

15. Nopal (*Opuntia tuna*)

FROM *The Badianus Manuscript*, BY J. BADIANUS AND M. DE LA CRUZ, *c.* 1552

This manuscript herbal was written and illustrated by two Mexican physicians in the college of Santa Cruz, and was probably intended for presentation to Charles V of Spain; it is now in the Vatican Museum. The remedies it propounds are those of Aztec medicine before the Spanish conquest, and include treatments for those frightened by lightning, for those about to cross a river, and for the fatigues of Government office.

Many of the plants, shown under now obsolete Mexican names, are impossible to identify; but this little miniature (brilliantly coloured in the original) clearly represents a species of prickly-pear, *Opuntia tuna*, long cultivated in Mexico as a source of nopal gum. With honey, yolk of egg and other herbs it was used for 'burns of the body'.

16. Basket-Flower and Little Stone-Amoxtli (*Xanthosma* sp?)

FROM *The Badianus Manuscript*, BY J. BADIANUS AND M. DE LA CRUZ, *c.* 1552

Two plants are shown in this picture; an arum called Basket-Flower, and Little Stone-Amoxtli, an unidentified moss or moss-like plant growing on a clod of earth. The former was probably a species of Xanthosma; no member of its family has toothed leaves but the artist may have been trying to indicate undulate margins. It was a much-treasured plant, used in temple offerings, in various remedies, and as a charm to safeguard the traveller. The moss, with ground many-coloured pebbles and other ingredients, was used in the treatment of an ulcerated throat.

F 3

14

Tlatoc Nochtli.

Corporis adustio.

Corporis nostri pars adusta adiuuatur succo ex Nohpal
li. Teamoxtli, Amoxtli, Tehmitl, hecapahtli, Texiyotl &
huitzquiltl, quo perunganda erit & confricanda cum
melle & oui uitello.

Huacalxochitl. Tepiton teamoxtli.

An gi na

Celi et gule suppurationem sanat caulis xaltomatl trite vna
cum teamoxtli, alba terra lapillis vel scopulis variegatis qui
e torrente colliguntur et acamallotetl, cum indicis spicis ma
le tritis et floribus huacalxochitl et tlauazquixochitl probe
expressus succus, quem gutturi subinde infundet.

16

17. Indian Shot *(Canna indica)*

FROM *Rariorum . . . Stirpium per Hispanias Observatarum . . .,* BY C. CLUSIUS, 1576

This little book was the first printed work by Charles de l'Ecluse or 'Clusius', who afterwards became one of the foremost European plantsmen—a link, one might say, between the last of the traditional herbalists and the first of the modern botanists. It records the 200 new plants he found in the course of an adventurous visit with two pupils to Spain and Portugal. Here for the first time he saw the Canna, brought by the Spanish from their possessions in the West Indies; and the picture he gives of it was probably the first to be published in Europe. He observed that the round, bullet-like seeds that give the plant its name of Indian Shot were used locally to make rosaries.

18. Spring Snowflake *(Leucojum vernum)*

FROM *Florum et Coronarium Odoratarumque . . .,* BY R. DODOENS, 1569

This very small herbal presents a selection of plants chosen for their ornamental rather than their medicinal properties, though the latter are not omitted; it is perhaps the earliest plant-book in which beauty is emphasized rather than use.

The snowflake here shown flowers even earlier than the snowdrop, and its blooms are larger, but it is not nearly so well-known—perhaps because it does not flower freely unless its particular wants are met. It lacks the excessive chastity of the snowdrop; there is a mischievous little twisted point at the tip of each of its six equal petals, than which nothing could be more charmingly frivolous. This is one of the standard Plantin woodcuts, and appears in several different books.

19. Hoop-Petticoat Daffodil *(Narcissus bulbocodium)*

FROM *Historia Generalis Plantarum,* BY J. D'ALECHAMPS, 1586–7

We have here permitted ourselves to reproduce a small illustration from a very large book—the elegant herbal of Jacques d'Alechamps of Lyons, which, like many such works, has three or four woodcuts to a page.

There is a whole wardrobe-full of these miniature hoop-petticoat daffodils, mostly now classed as sub-species and varieties of *Narcissus bulbocodium*. Three were known to d'Alechamps (one is on another page), and he has added another miniature, the enchanting *N. juncifolius*. All are beloved by Alpine gardeners, though only some are easily grown. *N. bulbocodium* is regarded as a relatively recent species, still in process of evolution—the narcissus, as it were, trying on a new dress. Nevertheless the 'novelty' probably dates back to the time when Spain and North Africa still formed a single land-mass.

Canna Indica.

NARCISSVS
montanus.

Narciſſus montanus omnium minimus.

Narciſſus montanus iuncifolius minimus alter, Lobel.

Narciſſus iuncifolius flore rotundo roſeo, Lob.

cauliculum gracilem & vacuum ferens , &
ratum, ſex foliolis conſtantem, & in medi

19

20. Wild Carrot *(Daucus carota)*
FROM *Historia sive Descriptiones Plantarum*, BY L. THURNEISSERUS, 1578

Leonhardt Thurneisserus was the only known botanist who was also a wizard. He had a medical practice and a private printing-press in Berlin, where he dispensed amulets, talismans and secret remedies, cast horoscopes and nativities and issued astronomical calendars. His book, of which only the first volume was ever completed, contains almost more astronomy than botany.

The plant here shown, surrounded by mystical trimmings, is the common carrot; but its aura is not so inappropriate as might be supposed. The Greeks valued it as an aphrodisiac, and called it Philtron. Its flower is characterized by having one dark-red or purple floret in the centre of the white umbel; this, and only this, was considered a valuable remedy for epilepsy. Sir J. C. Bose, who about 1927 conducted many experiments on the responses of plants to electrical stimuli, found the carrot 'very excitable' in comparison to the languid celery, which was 'easily fatigued'.

21. Moonwort, Unshoe-the-Horse *(Botrychium lunaria)*
FROM *Phytobasanos sive Plantarum Aliquot Historia*, BY F. COLONNA, 1592

Fabio Colonna (or Fabius Columna), descended from the princely Italian family of that name, was a highly cultivated man who first became interested in plants when seeking for a herb recommended by Dioscorides to cure the epilepsy from which he suffered. His *Phytobasanos* (= 'Plant Touchstone') was the first herbal to be illustrated by copperplates, not woodcuts; the etchings are believed to have been executed by himself.

Lunaria or moonwort is a slender little fern which, because of the crescent shape of its pinnae, has always been associated with moonlight and magic. It was believed to wax and wane with the moon, and to shine at night like a pearl. Its particular property was the loosening of bolts and nails; it was said that any horse that trod upon it would cast a shoe. Enterprising burglars would make an incision in the palm of the hand, and insert a slip of moonwort underneath; this would give them (if not septicaemia) a hand that could open bolts and bars at a touch. Though fairly common on heaths, this fern is so inconspicuous that it is more often present than seen.

22. Cobweb Houseleek *(Sempervivum arachnoides)*
FROM *Ecphrasis: Minus Cognitarum Stirpium Aliquot . . .*, BY F. COLONNA, 1606–16

The common houseleek, *Sempervivum tectorum*, has a large literature, chiefly concerned with its ancient use on roofs to ward off lightning; but in spite of its marvellous tracery of threads from leaf-tip to leaf-tip (which are the plant's own invention, and have nothing to do with spiders) the Cobweb Houseleek of the Alps seems to have acquired no particular traditions. Colonna was fascinated by the beauty and strangeness of the plant, and by the geometric figures formed by the threads—triangles, squares, pentagons and hexagons. Several species of these 'cobweb' houseleeks are cultivated, and many varieties and hybrids have arisen.

Iunÿ 6. D
⊙ in } ♋
♂ in } 69

גֶזֶר רְמֵעֲחַ:

Sulph. 6.
Sal. 3.
Merc. 3.

Oleago.
Balſamũ.
Sal.

Λυσίλιϑ☉.

Coſeruat.
Roborat.
Sanat.

20

Ἐπιμήδιον *Epimedium*

L

Sempervivum rubrum montanum γναφαλώδες

23. Anemones *(Anemone coronaria* vars.*)*

FROM *Le Jardin d'Hyver*, BY J. FRANEAU, 1616

This charming little florilegium is apparently rare. Its title of 'The Winter Garden' refers to the fact that such picture-books were regarded as substitute gardens for flower-lovers to look at during the winter. It consists of twenty-six 'Elegies' in verse on the most prominent cultivated flowers, in which, we are assured by a Professor of Theology, 'il n'y a chose contraire à la Foy Catholicque.' Unfortunately the Catholic faith did not deter Jean Franeau from thieving his garden frontispiece from the *Hortus Floridus* of Crispin de Passe, published two years earlier; and a close comparison would probably reveal that many of his figures of flowers, though differently arranged, were derived from the same unacknowledged source.

Franeau devotes seven plates to the anemone, one of the most popular flowers of the day. There were already so many varieties that, as Parkinson said, this one kind of flower 'is of it selfe alone almost sufficient to furnish a garden with their flowers for almost halfe the yeare.'

24. Various Gentians *(Gentiana lutea, G. verna, G. pneumonanthe* and *G. acaulis)*

FROM *Specimen Historiae Plantarum*, BY P. RENEAULME, 1611

This unusual book by a learned physician of Paris was among the first to have copperplate, not woodcut, illustrations; the rather dirty little etchings, which have been compared to those of Rembrandt, may have been the work of Reneaulme himself.

The gentians here depicted are probably *G. lutea*, the yellow gentian used in medicine since the time of the inebriate King Gentius of Illyricum (*c.* 170 B.C.), the tribe's namesake; *G. verna*, beloved of rock gardeners and a rare native of Britain; *G. pneumonanthe*, the Marsh Gentian or Calathian Violet, also a Britisher; and the Alpine *G. acaulis*. In Reneaulme's picture—possibly copied from an earlier source—this plant, unlike those now in cultivation under the name, is truly 'acaulis'—that is, stemless; it is as reprehensible for this kind of gentian to grow a stem as it would be for a human to grow a tail.

25. Spanish Broom *(Spartium junceum)*

FROM *Specimen Historiae Plantarum*, BY P. RENEAULME, 1611

After the invasion of Spain by the Carthaginians in 238 B.C., it was discovered that the fibres of the Spanish broom, which covered many barren acres, made excellent marine cordage, which improved rather than deteriorated when soaked in salt water. A mysterious reference in Homer, six hundred years before, to ships being sewn together with 'Sparta' should probably be read as 'Sarta', a cordage made from flax. 'What time as barges and vessels were sowed together with seames, it is well known', asserts Pliny confidently, 'that the stitches were made with linnen thred and not with Spart.' Presumably these needlework boats were made from hides; can the stitch used have been herring-boning? It is said that Homer's epic was based on an earlier poem written by a woman...

Anemone de merueille
 P

Berrurier fe.

23

Δασυστέφανη Ἡρικαλη Campl. Species Κυανη

Θυλατμκιτίς

Μακρολόβιον

Spartium

Ὑποσφαιρολόβιον

E

25

26. Sea-Daffodil *(Pancratium illyricum)*

FROM *Le Jardin d'Hyver*, BY J. FRANEAU, 1616

In the seventeenth century, every bulbous plant with strap-shaped leaves was a 'Narcissus', from the South African Agapanthus to the South American Zephyranthus. This 'Narcisse Mathiole' was a Pancratium, the older of the two European species (*P. illyricum* and *P. maritimum*) which were known to early writers as sea-daffodils. The latter in particular is as fond of the beaches as a sunbather, though it prefers shingle to sand. Both are Mediterranean plants, and tender in colder countries, but they are figured in nearly all the early florilegiums and were evidently in universal cultivation, perhaps for the sake of the sweet scent of their white flowers.

27. Trumpet-Vine *(Campsis radicans)*

FROM *Flora seu de Florum Cultura*, BY G. B. FERRARI, 2ND EDN., 1638

This delightful Latin gardening-book was originally published in Italian in 1633. It is lavishly illustrated with plans for parterres, pictures of tools and appliances, an assortment of allegorical personages variously employed and some astonishing examples of flower-arrangement. The few plant-portraits are by a lady, Anna M. Variana, about whom nothing is known.

These illustrations, to the section 'Of New Flowers', justify the title, for they show what were then some very recent introductions. Indeed, our reproduction may represent the very first picture of the American Trumpet-Vine, antedating by two years the one in Cornut's *Historia Canadensium Plantarum* of 1635. Cornut compared the flowers to thimbles; and Catesby (1730) tells us that in their native land 'the Humming-Birds delight to feed on these Flowers, and by thrusting themselves too far into the Flower, are sometimes caught.'

28. Belladonna Lily *(Amaryllis belladonna)*

FROM *Flora seu de Florum Cultura*, BY G. B. FERRARI, 2ND EDN., 1638

In the beginning, bulbous plants with leaves like a daffodil and flowers like a lily were sensibly called 'lilio-narcissus', and 'indicus' might signify India, the East or West Indies, or even parts of South America or Africa; actually this plant is a native of the Cape of Good Hope. It reached Britain in 1712 from Portugal, where it was extensively cultivated, and as late as 1804 its native land was still not certainly known: 'The channel through which the plant has been received', wrote John Sims in the *Botanical Magazine*, 'makes it more than probable that it is a Brazil vegetable.' It thrives out-of-doors in the warmest parts of Britain, and grows, but is reluctant to bloom, in sheltered corners elsewhere. Linnaeus playfully named it 'belladonna' (beautiful lady) from the radiant pink and white of its complexion.

Narciße Mathiole .5.

26

27

NARCISSVS INDICVS LILIACEVS DILVTO COLORE PVRPVRASCENS

29. Alpine Clematis *(Clematis alpina)*

FROM *Démonstrations Elémentaires de la Botanique*, BY J. E. GILIBERT, 4TH EDN., 1796

Pierre Richer de Belleval was appointed Professor of Botany at the university of Montpellier in 1593, and founded its celebrated Botanic Garden. He made many personal explorations of Provence and the Dauphiné, and sent his students as far afield as the Pyrenees; some 500 plant-drawings were engraved under his direction but were never published in his lifetime. His work was neglected by his successors and remained almost unknown until J.E. Gilibert visited Montpellier before taking up a botanical post in Poland, and was given the opportunity to purchase about 300 surviving plates. He added the Linnaean names to the plates and used such of them as were suitable to illustrate his subsequent book on Polish plants, and the rest in the fourth edition of his *Démonstrations Elémentaires de la Botanique*—more than 150 years after Belleval's death.

When dealing with a prostrate or cushion plant, Belleval frankly drew it sideways, as in this picture, where *Clematis alpina* is shown scrambling through rocks. In a good form, this variable Clematis is one of the most attractive of its genus; Robinson called it 'hardy as the oak, and tender in colour as the dove'. In the rock-garden it will ramble frailly over low-growing shrubs and give no trouble at all.

30. Archangel, Weasel-Snout *(Lamium galeobdolon)*

FROM *Exercita Phytologica*, BY J. E. GILIBERT, 1792

Belleval took the hints on design given to him by the plants and carried them to their logical conclusion. His 'Galeopsis' is almost unrecognizable—it is not usually so branching a plant—yet one cannot say that the drawing is untrue to life in any one particular. The Labiates tend to be rated as second-class plants, their often beautiful flowers being marred by poor quality, nettle-like leaves; though in aromatic and medicinal properties they are unsurpassed. 'Archangel' was said to be so named for its virtue in looking like a nettle, but carrying no sting.

31. Hawkweed *(Hieraceum hispidum)*

FROM *Exercita Phytologica*, BY J. E. GILIBERT, 1792

The generic name is derived from *Hierax*, a hawk, because falcons were believed to make use of a plant of this genus to sharpen their sight. It also sharpens the sight of botanists, who have distinguished more than 230 species and micro-species of hawkweed in the British flora alone. These varieties are of little interest to the gardener, as they are mostly more weed than hawk, with the exception of the orange-tawny Grim the Collier *(Hieraceum aurantiacum)*, a very old garden-plant, attractive in colour but apt to become invasive.

Atragene alpina L.
173.

29

LAMIVM ὀρεομηλινοωετρορρεπές.
pl. 22 C. M. P. 95. N. 24.

Galeopsis
galeobdolon. L.

30

pl. 45.

HIERACIVM AL... ϖολυκαυλορρεπες

P.185. N.91.

Leon = =todon hys= =pidum. L.

32. Six Ferns *(Adiantum, Ceterach, Polypodium, Asplenium* and *Phyllitis)*

FROM *A Compleat History of Druggs*, BY P. POMET, 1712

This, 'a WORK of very great use and Curiosity', was written by the chief druggist
to King Louis XIV. The plate reproduced shows what were then called the Five
Capillary Herbs, so named after the maidenhair, *Adiantum capillus-veneris* (literally
Hair of Venus). They were the maidenhair itself, used as a hair-tonic and for
pulmonary diseases; Ceterach or Spleenwort *(Ceterach officinarum)*, a very ancient
remedy for liver complaints; Polypody *(Polypodium vulgare)*, used in the Nether-
lands for arthritis, and by country women for whooping-cough; Wall Rue
(Asplenium ruta-muraria), also called Tent- or Taintwort for its use in 'tent'
or rickets, and Hart's Tongue *(Phyllitis scolopendrium)*, chiefly for burns and scalds.
To these Pomet adds a sixth fern, more esteemed than all the rest; the Canada
maidenhair *(Adiantum pedatum)*, which was 'cultivated with great Care in the
King's Garden at Paris' and prescribed for consumption and coughs.

33. Kurume Azaleas *(Rhododendron kaempferi)*

FROM *Amoenitates Exoticarum*, BY E. KAEMPFER, 1712

Only the fifth part of this travel book is concerned with plants; but it contains the
first European pictures and descriptions of a number of Japanese flowers now so
familiar in our gardens that we feel they have always been there. Dr Engelbert
Kaempfer served for a time as surgeon to the Dutch East India Company, and
spent two years (1690–1) on their tiny island of Deshima, in the harbour of
Nagasaki, the only foothold in Japan then allowed to Europeans. He made every
effort to study the Japanese flora, so far as his limited opportunities would permit,
and intended eventually to write a botanical book, but this never materialized.

This picture shows two varieties of the Japanese azalea now named after him.
It is the parent of many natural and garden hybrids, including those known as the
'Kurume' azaleas; Kaempfer describes fifteen of the kinds already grown by the
Japanese. It is said that the original wild form sprang from the soil of the sacred
Mt Kirishima, on the spot on which Ninigi alighted when he descended from
heaven to found the Empire of Japan.

34. Camellia *(Camellia japonica* var.)*

FROM *Amoenitates Exoticarum*, BY E. KAEMPFER, 1712

Kaempfer was obliged to illustrate his plants under their Japanese names, as
many of them had as yet no European ones. His 'Tsubaki' was the second published
picture of a camellia, the first (in 1703) having been drawn only from a dried
specimen. Kaempfer says that in Japan the wild camellia grew in every hedge,
but that there were many cultivated garden varieties. One with double flowers as
big as a rose was called 'Dsisij', meaning 'little lion-dog' (i.e. the Pekinese), 'a
name it has received for its pleasing flowers'.

A pencilled note on this plate in the Lindley Library copy of the book reads
'nearest the thea plant, flowers at Ld Petre's.' Young Lord Petre, who died of
smallpox in 1743, was the first in England to grow the camellia; but the source of
his plants is unknown.

Book 5.
of Leaves.

7

Plate 33.

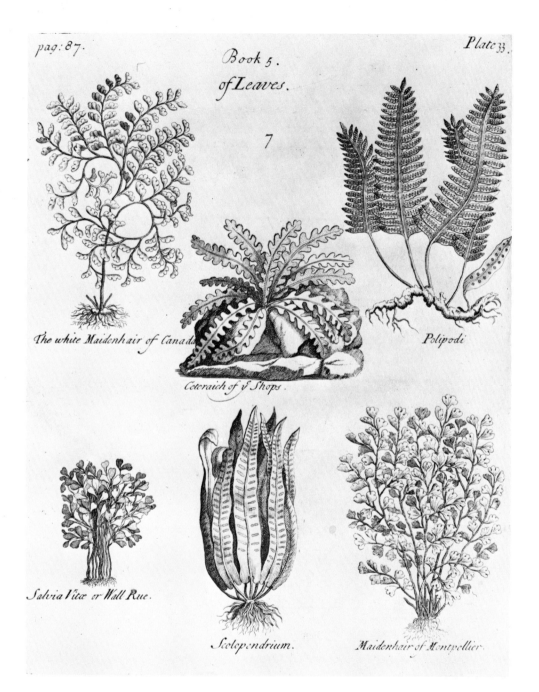

The white Maidenhair of Canada

Polipodi.

Cetcraich of ẏ Shops.

Salvia Vitæ or Wall Rue.

Scolopendrium.

Maidenhair of Montpellier.

Chih Chuk 躑躅 Siu Tsusi

VB

Chamæ rhododendron, mollort, Luçana . Bibrans

33

Tfubaki

34

35. Title-page

FROM *Variae ac Multiformes Florum*, BY N. ROBERT, *c.* 1660

This lovely title-page wreath shows Robert at his best. It must be admitted that the artist seems to have been economical of his efforts; his three florilegium-type books (as distinct from his later botanical work) all have the same title in different languages, and two of them at least share many of the same plates. *Fiori Diversi* was published in Rome in 1640; the other two, the *Variae ac Multiformes Florum* and the *Diverses Fleurs*, are undated. The latter is probably the second, for it adds forty (slightly inferior) plates to the *Variae's* original thirty-one; in the Lindley Library copy the pictures are gaily coloured with a happy disregard for nature, presenting grey daffodils and red globe-flowers.

36. Auricula *(Primula × pubescens)*

FROM *Variae ac Multiformes Florum*, BY N. ROBERT, *c.* 1660

The auricula so sensitively engraved by Nicolas Robert is curiously unlike the flower as it is today; although it had already been grown by florists for more than thirty years, the circular central eye and rounded overlapping petals had hardly yet been developed. 'Wee have White, Yellowes of all sorts, Haire colours [i.e. browns], Orenges, Cherry colours, Crimson and other Redds, Violetts, PURPLES, MURREYS, TAWNEYS, OLIVES, CINNAMON Colours, ASH color, DUNNS and What not?', wrote Sir Robert Hanmer, a contemporary fancier, who got many of his auriculas from France. 'But wee esteem most such as have great and white eyes in the middle of the flowers, and most flowers on a stalke, if it be strong and high.' Robert's specimen lacks the first qualification, but has the second.

37. Hyacinth and Love-in-a-Mist
(Hyacinthus orientalis and *Nigella damascena)*

FROM *Diverses Fleurs*, BY N. ROBERT, *c.* 1660

When ex-King Ferdinand of Bulgaria made a garden of Japanese plants at his palace on the Black Sea, he also imported Japanese butterflies, so that the flowers should not feel lonely. Something of this companionable spirit seems to imbue plant-illustrations in the Dutch tradition, where the flowers are often accompanied by insects, but neither are treated in a scientific manner. Nor are the associations of the flowers themselves any less casual; the double hyacinth and the nigella might have been picked at random from any seventeenth century garden—though not, one would expect, at the same time of year. There is no reason for their juxtaposition other than that both pleased the artist. At that time the double hyacinth was thought the only kind worth growing.

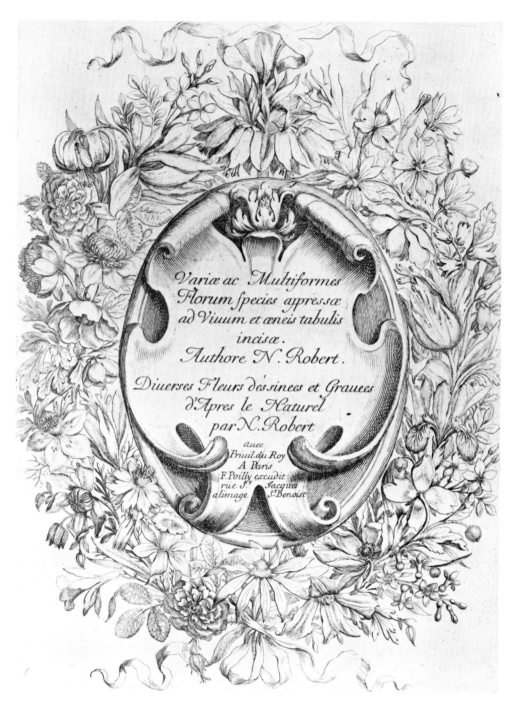

Variæ ac Multiformes
Florum species appressæ
ad Viuum et æneis tabulis
incisæ.
Authore N. Robert.

Diuerses Fleurs dessinees et Grauees
d'Apres le Naturel
par N. Robert

auec
Priuil.du Roy
A Paris
F. Poilly excudit
rüe St Jacques
alimage St Benoist

35

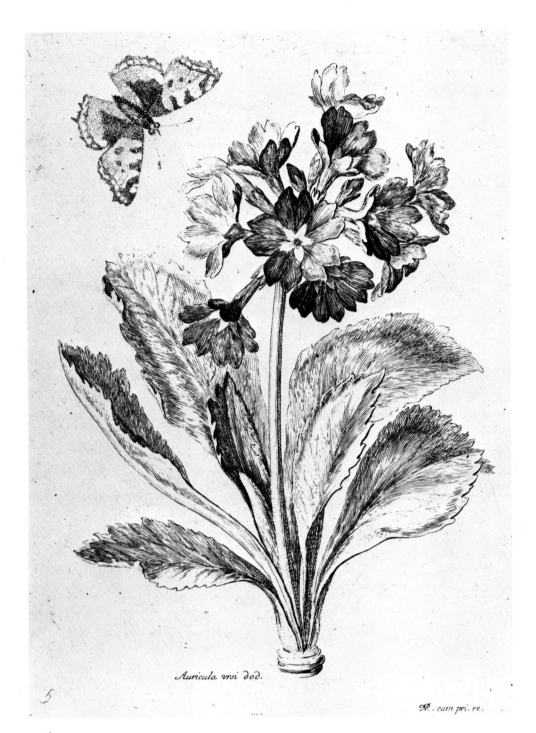

Auricula ursi dod.

5

ℛ. cum pri. re.

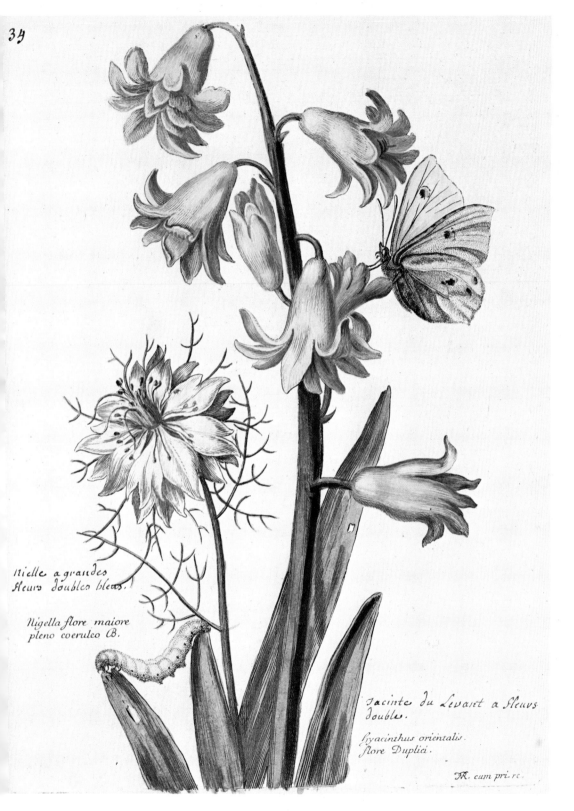

Nielle a grandes
fleurs doubles bleus.

Nigella flore maiore
pleno coeruleo B.

Jacinte du Levant a fleurs
double.

Hyacinthus orientalis.
flore Duplici.

M. cum pri re.

38. Dog's-Tooth Violet *(Erythronium dens-canis)*

FROM *Apparatus Plantarius Primus*, BY P. LAUREMBERG, 1632

Besides two 'books' on bulbous and tuberous plants, Lauremberg wrote a two-book *Horticultura* (1631)—the four together making a volume hardly so large as an ordinary novel. The brilliant little engravings were done by Matthias Merian, father of Maria Sybilla Merian (see Plates 50, 51 and 52).

The Dog's-Tooth Violet is a misnamed plant, for the root, which resembles a dog's tooth, is invisible above ground, while the flower has not the remotest likeness to a violet, except that it blooms in the spring. In the old days it was associated with certain orchids because of its spotted leaves, and called, like them, satyrions (after the satyrs, because of some supposed aphrodisiac properties), a name that seems to suit it better, at least as regards the European species; the American ones have a somewhat more innocent look. All are among the most enchanting spring flowers that can be grown, and look, as they are, miniature lilies.

39. March

FROM *The Flower Garden Display'd*, BY R. FURBER, 1734

Robert Furber was an enterprising nurseryman, who in 1730 issued the first illustrated nurseryman's catalogue—a handsome folio called *The Twelve Months of Flowers*, with pictures designed by the Flemish artist Pieter Casteels. All the plants shown were to be had from Furber's Kensington nursery; but nothing so vulgar as a price was mentioned. This enterprise having been a success, Furber produced *The Flower Garden Display'd*, a cheap edition with the original plates copied on a smaller scale, not altogether successfully, by a different engraver.

Tulips, hyacinths, auriculas, anemones and other florist's flowers naturally feature largely in these nurseryman's bouquets; but many less familiar flowers are also shown, including twenty-five American species. In the March group there are two transatlantic Acers—the 'American flowering Maple' and the 'Virginian flowering Maple'—besides the Norway maple.

40. November

FROM *The Flower Garden Display'd*, BY R. FURBER, 1734

Looking at Furber's prints one would think that the month of November was the gayest in the garden; but to this day gardeners write in this month to the papers, giving long lists of plants still in bloom, when early frosts have not been too severe. If some of the November flowers shown by Furber are no longer grown, it is because the weather, rather than the plant, is unreliable. A few are regular late bloomers, such as the laurustinus and arbutus; others are left-overs from the summer, or tender plants temporarily enfranchised from the greenhouse.

Furber claimed that his book was 'Very useful, not only for the Curious in Gardening, but the Prints likewise for Painters, Carvers, Japaners etc., also for the Ladies as Patterns for Working, and Painting in Watercolours, or Furniture for the Closet'.

PETRI LAVREMBERGI
CAPVT VII.

DENS CANINUS.

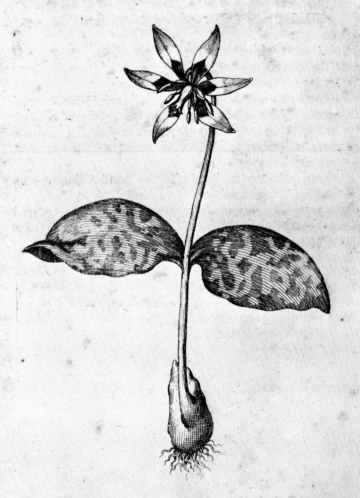

MARCH

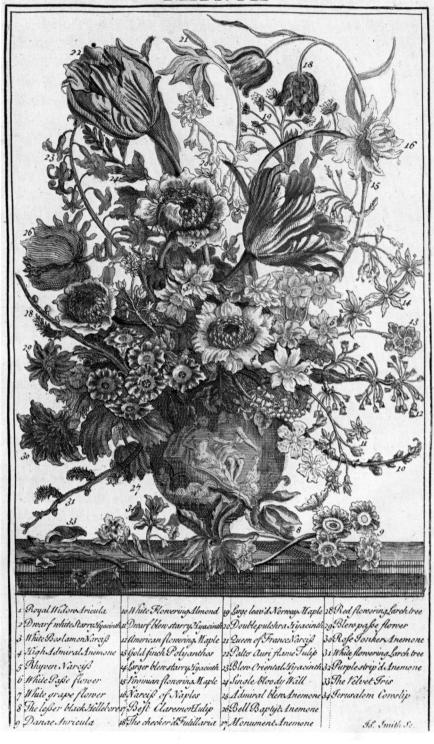

1 Royal Widow Auricula	10 White Flowering Almond	19 Large leav'd Norway Maple	28 Red flowering Larch tree
2 Dwarf white starry Hyacinth	11 Dwarf blew starry Hyacinth	20 Double pulchra Hyacinth	29 Blew passe flower
3 White Roslam on Narciss	12 American flowering Maple	21 Queen of France Narciss	30 Rose Jonker Anemone
4 High Admiral Anemone	13 Goldfinch Polyanthos	22 Palto Auri flame Tulip	31 White flowering Larch tree
5 Rhyven Narciss	14 Larger blew starry Hyacinth	23 Blew Oriental Hyacinth	32 Purple strip'd Anemone
6 White Passe flower	15 Vovinian flowering Maple	24 Single bloody Wall	33 The Velvet Iris
7 White grape flower	16 Narciss of Naples	25 Admiral blew Anemone	34 Jerusalem Cowslip
8 The lesser black Hellebore	17 Best Claremont Tulip	26 Bell Baptist Anemone	
9 Danae Auricula	18 The checker'd Fritillaria	27 Monument Anemone	

Jn. Smith Sc.

39

NOVEMBER

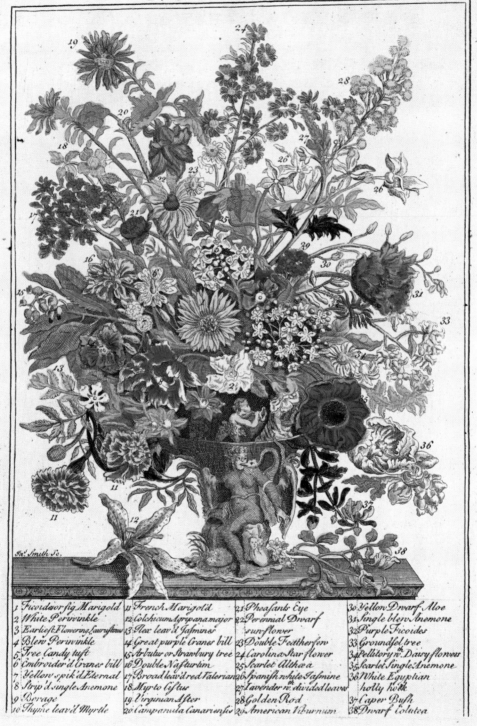

Fd. Smith Sc.

1 Ficoidæ or fig Marigold	11 French Marigold	21 Pheasants Eye	30 Yellow Dwarf Aloe
2 White Periwinkle	12 Colchicum Agrippana major	22 Perennial Dwarf	31 Single blew Anemone
3 Earliest Flowering Laurustinus	13 Flex leav'd Jasmine	sun flower	32 Purple Ficoides
4 Blew Periwinkle	14 Great purple Cranes bill	23 Double Featherfew	33 Groundsel tree
5 Tree Candy tuft	15 Arbutus or Strawbury tree	24 Carolina Star flower	34 Pellitory w. Daisy flowers
6 Embroider'd Cranes bill	16 Double Nasturtium	25 Scarlet Althæa	35 Scarlet Single Anemone
7 Yellow spik'd Eternal	17 Broad leav'd red Valerian	26 Spanish white Jasmine	36 White Egyptian
8 Strip'd single Anemone	18 Myrto Cistus	27 Lavender w. divided leaves	holly hock
9 Borage	19 Virginian Aster	28 Golden Rod	37 Caper Bush
10 Thyme leav'd Myrtle	20 Campanula Canariensis	29 American Viburnum	38 Dwarf Colutea

41. Fig-Marigold *(Sceletium expansum)*
FROM *A History of Succulent Plants*, BY R. BRADLEY, 1716–27

Publication of this book, which appeared serially in five parts, was delayed, said the author, because 'the Spirit of Botany was not powerful enough to pay the Expence of engraving the Copper-Plates'. The lively drawings were Bradley's own work, but the Spirit of Botany only afforded a very second-rate engraver.

All Bradley's 'Fig-Marigolds' were formerly classed as Mesembryanthemums, but this enormous genus has since been divided for convenience into a number of others, and the species illustrated has become *Sceletium expansum*. This sprawling and sinister plant, like most of its tribe, is a native of South Africa; and the roots were chewed or smoked by the Hottentots as a stimulant and narcotic, with effects similar to cocaine. It was also reputed to be a hallucinogen; but one would think any visions it induced would not be pleasant ones.

42. Livingstone Daisy *(Dorotheanthus bellidiformis)*
ORIGINAL WATERCOLOUR BY ANNE LEE, *c.* 1777

Mesembryanthemum is one of those vast genera whose large numbers and relative accessibility (most of them being natives of South Africa) encourage gardeners to make 'collections'. The nurseryman James Lee was one such specialist. By 1774 he had amassed fifty-four different species, so it is natural that among the few surviving specimens of his daughter's work there should be a set of sixteen mesembryanthemums: they are exquisitely painted on vellum and dated between 1776 and 1778. The example reproduced, now renamed *Dorotheanthus bellidiformis*, is the parent of the annual Livingstone Daisies that make our summer gardens so gay—when the sun shines. Samuel Ryder, founder of the seed-firm of that name (and of the Ryder Cup golf trophy), saw this flower in 1928 in the Kirstenbosch Botanic Garden in Cape Town, where it was regarded as a weed, and asked for all the seed of it that could be supplied; but to market it he needed an English name, and he christened the flower after his hero, the missionary-explorer David Livingstone, who had had a camp nearby.

43. Saffron Crocus *(Crocus sativus)*
FROM *Icones Plantarum Medicinalium*, BY J. ZORN, 1780

Apart from the multi-purpose herbals, four works on medical botany are represented in our book; and there are many others with fine plates, British and foreign, large and small. They belong to a time when doctors were directly concerned with healing herbs, with less intervention from the chemist, and it was necessary for them and their suppliers to be able to identify the plants correctly. Zorn's book ran to six volumes, each of a hundred coloured plates; but the usefulness of some of the species shown is open to doubt.

Saffron, however, had been used extensively from times of the greatest antiquity as a condiment, a medicine, a disinfectant and a dye. Yet the product consisted only of the dried stigmas of the flower; it took approximately 40,000 blossoms to yield a pound. It was universally believed to provoke mirth and merriment; an overdose could cause dangerously uncontrollable laughter, and a habitually cheerful person was said to have slept on a sack of saffron. Unfortunately its use has now almost died out.

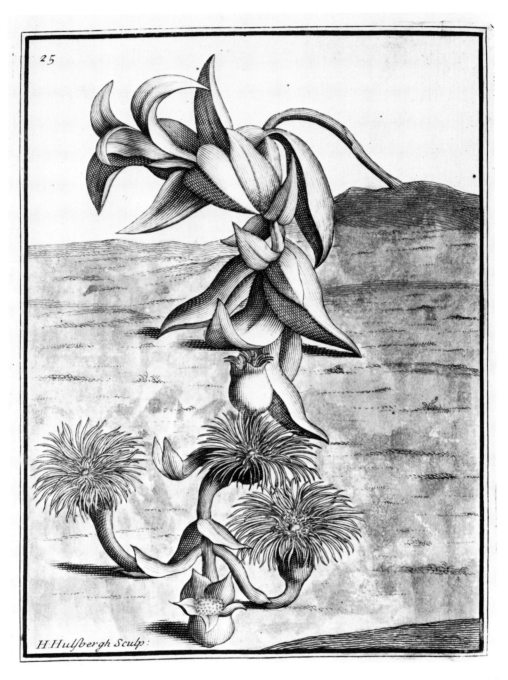

42

Tab.151.

Crocus sativus. L.

B. Thanner del. I. S. Leitner fec.

44. Saffron Crocus *(Crocus sativus)*

FROM *Flora Britannica Indigena*, BY J. WALCOTT, 1778

Walcott was mistaken in thinking the Saffron Crocus a native of Britain; it has been naturalized here and there, but has now died out. Legend relates that it was introduced, perhaps in the fourteenth century, by a pilgrim, who at peril of his life smuggled a bulb to Saffron Walden, Essex, concealed in a hollow staff. At any rate, this valuable commodity was cultivated there sufficiently early, and in sufficient quantity, to give the town its name and coat of arms. Nobody quite knows the origin of the cultivated saffron, which is sterile, and differs from the nearest surviving wild species in having drooping, not upright stigmas. In medieval times the penalty for adulteration was death; in 1444 a fraudulent apothecary of Nuremberg was burnt alive in the same fire as his adulterated saffron.

45. Asparagus *(Asparagus officinalis)*

FROM *Flore Médicale*, BY CHAUMETON, CHAMBERET AND POIRET, 1814

From the time of the epicurean Romans, who grew it about 200 B.C., asparagus has been the standard of comparison for all aspiring vegetables; but nothing is truly like asparagus, the delicacy of whose flavour reminds us that we are eating the shoots, botanically speaking, of a lily. It has crept into a medical book because it can be used as a diuretic and as a sedative for the heart; at Aix-les-Bains part of the treatment for rheumatism was to eat asparagus. In China it was grown for ornament, under the name of Dragon's Whiskers, and the feathery fronds are sometimes used by florists, but kitchen-gardeners frown on the female plants that bear the bright berries, as they produce unwanted seedlings which are hard to eradicate.

This lovely drawing by P. J. F. Turpin is reproduced from a special copy of the book, formerly owned and retouched by the artist himself.

46. Anemone *(Anemone pavonina)*

ORIGINAL WATERCOLOUR BY P. J. F. TURPIN, BEFORE 1840

This album of twenty-five exquisite watercolours on vellum shows Turpin (see Biographical Notes, p. 20) to have been a master of the miniature. The drawings may have been intended for a longer work that was never finished, as nearly all the surviving subjects are members of one family, the Ranunculaceae. A fire having unfortunately occurred in the library of a previous owner, some of the plates, including the present one, were slightly damaged by water, the damage in this case being confined to the heading, which has been omitted in the reproduction.

The anemone first sprang from the blood of Adonis, killed by a wild boar when hunting on Mt Lebanon—'Stony Lebanon, where grows His red Anemone'. It is hard to believe that Turpin's elegant little wild flower was part-parent of the clumsy great blooms now so popular as cut-flowers in winter, but which no seventeenth-century connoisseur would have acknowledged.

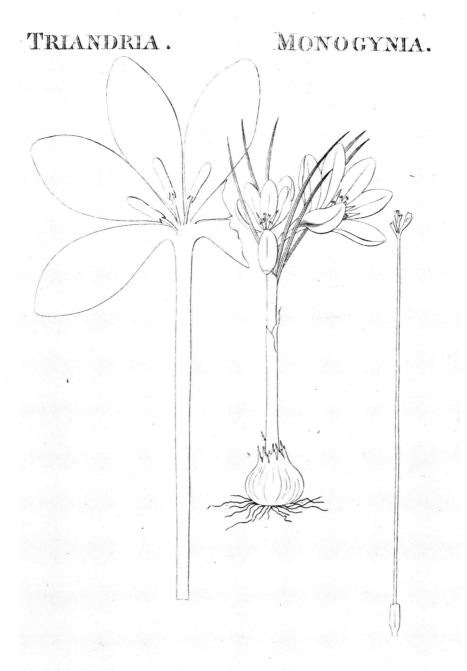

Crocus *sativus*. *Saffron*. *spatha univalvi,*
radicali; corollæ tubo longissimo.
Annual. August. About Cambridge.

44

ASPERGE.

Turpin pinx.t

ANÉMONE œil de paon.
ANÉMONE pavonina.

46

47. Title-page
FROM *The Compleat Florist*, 1747

The Compleat Florist is quite distinct from *The Florist* (Plates 62, 65 and 68), published about fifteen years later. Both are of doubtful or unknown authorship, and both show much the same sort of flowers; but the former is addressed to the gardener rather than to the amateur flower-painter, and although neither book has any appreciable text, *The Compleat Florist* has brief cultural directions engraved at the foot of each plate. Unfortunately the engravings are of poor quality and colouring, hardly worthy of the attractive title-page. A horrible Madonna Lily with pink stripes on the flowers, evidently some gardener's pride and joy, is shown both in the book and on the title-page; fortunately it is now extinct.

48. Early Purple Orchid *(Orchis mascula)*
FROM *English Botany*, BY J. SOWERBY, 1799

Works whose serial publication covered a long period were apt to include the most ornamental subjects in the earliest volumes, in the attempt to attract subscribers. The first of the 2,592 plates in *English Botany* shows the rare and beautiful Lady's Slipper Orchid; but the common and hardly less beautiful Early Purple Orchid perhaps better represents our flora and the series as a whole.

From the time of the Ancient Greeks, the resemblance of the twin tubers of this plant to a pair of testicles gave it a quite unwarranted reputation as an aphrodisiac. By the eighteenth century this belief seems largely to have died out; but a thin, hot gruel made from the dried and powdered roots was sold under the name of 'saloop' at the street-stalls and coffee-shops of London. It was believed to be exceptionally wholesome and nutritious, and was extremely popular. This concoction was of Oriental origin (Arabic, 'tha' leb', fox orchid) and most of the tubers for its manufacture were imported from Turkey.

49. Common Barley *(Hordeum vulgare)*
FROM *Flora Rustica*, BY T. MARTYN, 1794

Professor Thomas Martyn's book, in four small volumes, concerns plants 'useful or injurious in husbandry'—categories which, taken together, cover a rather wide field.

Forms of barley were cultivated in the Stone Age and the use of malted barley for brewing was known to the Ancient Egyptians before 1300 B.C.; Britons were making beer before the Roman invasion. An old ballad relates all the terrible things that were done to 'John Barleycorn'—

> *They took a plough and ploughed him down*
> *Put clods upon his head*
> *And they hae sworn a solemn oath*
> *John Barleycorn was dead . . .*

before he finally emerges triumphant as a pot of ale. But actually the legend stems from a far older myth—that of the king or god who must be slain and buried, in order that he may rise again and bless mankind.

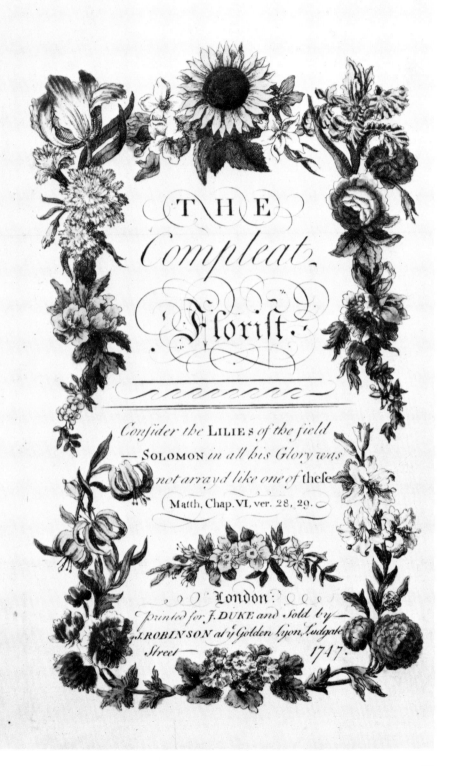

THE

Compleat

Florist.

Consider the LILIES of the field
— SOLOMON in all his Glory was
not array'd like one of these

Matth, Chap. VI. ver. 28, 29.

London:
Printed for J. DUKE and Sold by
J. ROBINSON at ye Golden Lyon, Ludgate
Street — 1747.

631.

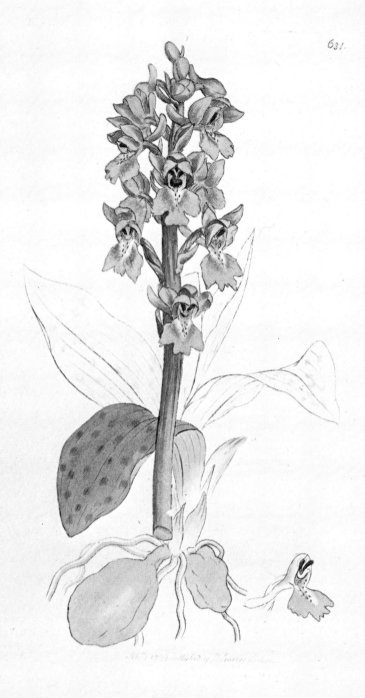

Drawn, Engraved & Published April 1794, by F. P. Nodder, N.º 15. Brewer Street. Golden Square.

90

2*49*

50. Dandelion *(Leontodon taraxacum)*

FROM *Erucarum Ortus, Alimentum et Paradoxa Metamorphosis,* BY M. S. MERIAN, 1717

Maria Sybilla Merian is chiefly renowned for her enterprising journey in 1698 to investigate the insects of Surinam (Guiana) and their food-plants; and for the fine folio on the subject which she afterwards produced. But before making this voyage she had already spent years of study on European insects; she was the first to observe and comprehend the metamorphosis of insects from caterpillar to chrysalis and to butterfly or moth. Her insects are nearly always shown on appropriate plants, drawn and engraved by herself with great skill; no exotic could surpass in beauty the common dandelion, as she reveals it. *Erucarum Ortus* (='The Origin, Food and Marvellous Transformation of Caterpillars') is a Latin edition of her first book (originally printed in Dutch and German), which was published as a memorial by her daughter, shortly after Maria's death in 1717.

51. Rose *(Rosa 'centifolia rubra')*

FROM *Erucarum Ortus . . .,* BY M. S. MERIAN, 1717

As gardeners sadly know, the rose is subject to a great many insect pests, which they cannot quite regard with the loving detachment of the entomologist. William Blake summed it up, many years later:

> *O rose, thou art sick*
> *The invisible worm*
> *That flies in the night*
> *In the howling storm*
> *Has found out thy bed*
> *Of crimson joy,*
> *And his dark secret love*
> *Does thy life destroy.*

52. Stock *(Matthiola incana var.)*

FROM *Erucarum Ortus . . .,* BY M. S. MERIAN, 1717

The stock-gillyflower, to give it its full name, has so long been grown in gardens that by 1629 it was already regarded as an old-fashioned flower. It seems to have been a particular favourite in Germany, where it was cultivated as a florist's flower by the weavers of Upper Saxony. It is said that in order to keep the shades distinct, only one colour or variety was allowed to be grown in each village; and the seeds were then packed and exported in collections of about forty named sorts. (But this was a hundred years or more after Maria Merian's day.) Only the double varieties were valued, and many devices were employed in order to raise them. Of course, no serious gardener would dream of sowing the seed except in the right aspect of the moon.

53. Chile Strawberry *(Fragaria chiloensis)*

FROM *A Voyage to the South Sea . . .*, BY A. F. FRÉZIER, 1717

King Louis XIV of France 'having been at vast Expence to support his grandson upon the throne of *Spain*' took advantage of a temporary cordiality between the two nations to send an emissary to investigate the closed territories of Spain's possessions in South America. Amadée François Frézier, a military engineer and hydrographer, was sent, frankly, as a spy, but his observations included natural history, and there is much in his book about plants. In cultivation near Concepción in Chile he found a large-fruited strawberry, unlike any he had seen, and on his return in 1714 he brought some plants back with him, although owing to the shortage of fresh water and other difficulties, only five survived the voyage. A few years later one of them was crossed with the Virginian strawberry (*F. virginiana*, introduced before 1629) and from this union all our modern strawberries are derived, the European species playing no part.

Frézier was descended from some Scottish Frazers who settled in Savoy in 1599, and whose appropriate badge was three strawberry-flowers—'Frazirs' in Scots heraldry.

54. Frontispiece

FROM *Flora Campana seu Pulsatilla*, BY G. A. HELWING, 1719

This is the commencement of a very remarkable book; remarkable because few monographs were produced at so early a date, remarkable in its choice of subject and in the fact that the author, the pastor of Angerburg, a remote district of East Prussia on the borders of Poland (perhaps the village shown in the picture) was conversant with the most advanced botanical science of his time. In a bibliography he cites eighty-five authorities consulted, some of them English or French, and some only recently published. Like his predecessors Bauhin and Tournefort he classed the Pulsatillas as a distinct genus of some fifteen species; it was Linnaeus, much later, who 'with a Boldness perhaps too great' put them among the Anemones—a merger of which some botanists have never approved and still do not recognize as valid. The name Pulsatilla (from *pulsare*, to shake or beat) dates from classical times and was given because the flowers came at a season when they were much beaten about by the wind.

55. Pasque-Flower *(Pulsatilla patens)*

FROM *Flora Campana seu Pulsatilla*, BY G. A. HELWING, 1719

The first part of Helwing's book is devoted in great detail to botany, the second to medical uses and the third to other uses and local superstitions. This, the second of his twelve plates, was actually a slightly clumsy copy, in reverse, of one published by his contemporary Jacob Breyne of Danzig, who is quoted in the text. It shows *P. patens*, a North European species very similar to our native *P. vulgaris*. As to the medical preparations, Helwing speaks of the roots, seeds, a distilled water, a syrup of the flowers and Pulsatilla wine. The pasque-flower has been praised quite recently as a remedy for arthritis; but actually it is a poisonous plant, and the name of 'Laughing Parsley' was given to it in the belief that anyone eating it would literally die of laughter—though the ghastly grin it left on the face of the corpse was not caused by merriment.

Linum
vulgo

montanum Luteum
ñancolahui.

Fragaria Chiliensis
fructu maximo, foliis
carnosis, hirsutis
vulgo frutilla.

N. Guérard le fils fecit.

Fraise du Chili dessinée de grandeur naturelle.

53

Pulsatilla Polyanthos
Anemones folio.

55

56. Mezereon, Paradise Plant *(Daphne mezereum)*

ORIGINAL DRAWING BY C. AUBRIET, BEFORE 1742

Claude Aubriet (1665–1742) prepared these pen-and-wash drawings to illustrate a botanical book that unfortunately never materialized. There are 668 of them, uniform in size, and nearly all signed, complete and ready for the engraver. Very few of them have ever been reproduced—to the world's great loss. They are not dated.

Aubriet's drawing shows this favourite plant bearing its ornamental red fruits. This is a sight becoming increasingly rare in Britain, where greenfinches have taken to pillaging the berries before they are ripe—a destructive habit so far unknown on the Continent. All parts of the plant, including the berries, are poisonous; but it has been used in medicine, and 'Mazaryun' (=mezereon) was the name given to it by Arabian physicians of the first century A.D. The Somerset name of Paradise Plant might refer not to the Daphne's charms and ambrosial perfume, but to the old concept of a 'paradise garden'—an enclosure or park planted with trees and shrubs, where exotic animals were kept. Francis Bacon, Lord Verulam, had a paradise garden at Gorhambury in Hertfordshire, and another at Twickenham. The Mezereon would be very suitable for such a plantation.

57. Musk-Rose *(Rosa moschata)*

ORIGINAL DRAWING BY C. AUBRIET, BEFORE 1742

Milton associates the musk-rose with what he rather strangely calls the 'glowing' violet, and Shakespeare rightly plants it on Titania's bower, as it was the only climbing rose known in his day; the eglantine or sweet-briar never attains any great height. Although cultivated for centuries in Europe and the Near East, this rose came originally from the Himalayas; and its nocturnal fragrance is said to emanate from the stamens rather than the petals of the flower.

This is one of the few unfinished drawings in the collection; yet not even Redouté could have portrayed the fragile flower with greater tenderness. How did Aubriet contrive to make this and the violet look fragrant?

58. Sweet Violet *(Viola odorata)*

ORIGINAL DRAWING BY C. AUBRIET, BEFORE 1742

However demurely it may hang its upside-down head (the lowest petal should properly be the topmost) the violet is not modest when it comes to its sexy perfume, which caused it to be made the flower of Aphrodite. The scent's principal ingredient, ionine, quickly fatigues the sense of smell, so that it can no longer be perceived, and therefore seems fugitive—'the perfume and the suppliance of a minute'.

'The violet is better that is gathered in the morninge' as William Turner wrote 'whose vertue nether the heate of the sun hath melted away, nether ye rayne hath wafted and driven away . . .'

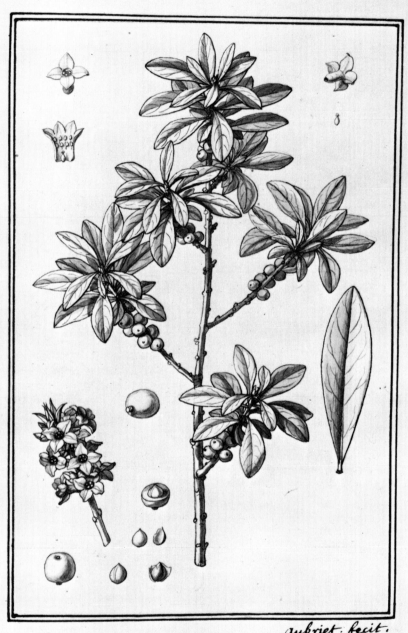

aubriet. fecit.

56

Rola moschata flore pleno C.B.Pin.
Rose muscade a fleur double.

57

Viola martia purpurea, flore simplici odoro.

C. B. Pin. 199.

59. Goat's Beard, Jack-go-to-bed-at-noon
(*Tragopogon pratensis*)
ORIGINAL DRAWING BY C. AUBRIET, BEFORE 1742

The Goat's Beard is one of the handsomest of our dandelion-like plants, with a particularly beautiful seed-head—not shown by Aubriet, though he does full justice to the plume of the individual seed. It is closely related to the salsify (a similar plant but with a slaty purple flower)—a vegetable delicate in flavour, but now neglected because its small roots are too much trouble to prepare. The name of Jack-go-to-bed-at-noon explains itself—the flowers close at midday; it was one of the plants listed by Linnaeus for his 'floral clock', on which the time might be told by the punctual opening or shutting of the flowers. In parts of France it was one of the magic herbs that were plucked on St John's Eve (23 June).

60. Rosemary *(Rosmarinus officinalis)*
FROM *Herbarium Vivum* BY J. H. KNIPHOF, 1761

A special press was set up at Erfurt in 1761 to print the twelve volumes (1,200 plates) of the *Herbarium Vivum* of Johann Hieronymus Kniphof, the most celebrated of several books that were illustrated by 'nature-printing'. This was a process by which dried specimens of the actual plant were inked and passed through the press—as can be imagined, a slow and tedious business; the specimens wore out after a few impressions and had to be replaced by others. The results were of undoubted accuracy, but apt to lack the clarity of detail of a good drawing, especially when, as in Kniphof's case, the prints were afterwards rather heavily hand-coloured. It is surprising that so complex a plant as rosemary should have responded so well to this treatment.

This beloved Mediterranean herb was introduced to Britain possibly by the Romans, and certainly by Queen Philippa of Hainault in 1338. Long lists of its uses appear in several old manuscripts and herbals, perhaps best epitomized in Bancke's instruction of 1525—'Smell it oft, and it shall keep thee youngly.'

61. Chinese Rose
ORIGINAL WATERCOLOUR, *c.* 1800

This picture is to be enjoyed for itself alone, for it has no recorded history. It comes from a small album of Chinese drawings in the possession of the Royal Horticultural Society—an album of which nothing is known except that it was probably made in Canton about 1800. There are no signatures, page numbers, dates or inscriptions, except on one page, which was 'marked by Wang-liu Chi'; and it is impossible to identify the rose, except as a garden variety. Many of the drawings in the book are of groups of fruit, including a brilliant study of a half-peeled banana; the style is European rather than Chinese and the book was obviously designed for the foreign market.

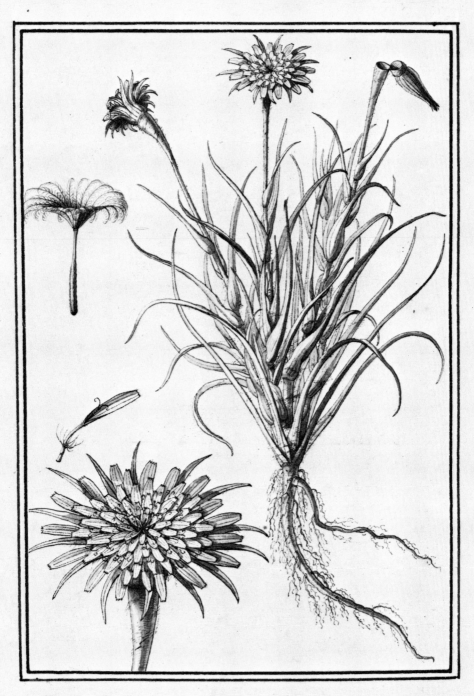

Tragopogon pratensis, luteum

62. Title-page

FROM *The Florist*, BY R. SAYERS AND OTHERS, *c.* 1760

This title-page explains itself; it is only necessary to add that the four booksellers mentioned also supplied the necessary painting-materials 'at the most reasonable Rates' and that the plates are believed to have been drawn by Robert Sayers. There is no text apart from the instructions for colouring, where we are assured that 'the Rules, that will here be laid down, for the executing the pleasing Branch of painting, of which this Book is to treat, are the Result of real Practice, and delivered without the least Reserve.'

63. Catesby's Gentian *(Gentiana catesbaei)*

FROM *American Medical Botany*, BY J. BIGELOW, 1819

Dr Jacob Bigelow's book was the first to be printed in colour in America. It is a little tentative; some of the plates in the first volume seem still to be coloured by hand, others are printed only in tones of green, and the colour varies greatly from one copy to another. Still, it *is* a colour-printed book, and the colour, though often simple, is always pleasing.

Of all the American species of Gentian, Bigelow thought *G. catesbaei* approached most nearly in its medical virtues to the European *G. lutea*, the species originally discovered and used by King Gentius of Illyricum. There is some evidence that this King was an alcoholic, and Ruskin tried to get the genus renamed 'Lucia', because Gentius, he primly asserted, 'was by no means a person deserving of so consecrated a memory'. Although known by repute since 1688, *G. catesbaei* does not seem to have been grown in Britain till 1803; 'as its stems are altogether low and neat', we are told, 'it may be placed near to the front of the parterre.'

64. Bleeding Heart *(Dicentra eximea)*

FROM *The Botanical Register*, ED. S. EDWARDS, 1815

The new *Botanical Register* illustrated in its first volume what was then a very new plant, brought from North America by the plant-hunter John Lyon as recently as 1812. It was classed as a fumitory—a genus which had by some been divided into Corydalis and Fumaria, 'but the editors of the *Hortus Kewensis* [Aiton's *Hortus Kewensis*, 2nd edn., 1810–13] have not been seduced into so wanton an innovation'. It has since been accommodated in the newer genus of Dicentra. Fifty years ago this easily grown plant was so common in gardens as almost to have become a weed, but it is now less often seen. It suffers from having been eclipsed by a supremely beautiful Chinese cousin, *D. spectabilis*, which since its introduction in 1846 has taken all the limelight, but which is not nearly so easy to grow. Both species can be forced in a greenhouse, but *D. eximea* 'requires less excitement'.

THE

FLORIST

Containing *Sixty Plates* of the most
beautiful *Flowers* regularly dispos'd
in their *Succession of Blowing* —

To which is added

an *Accurate description* of
their *Colours*, with *Instructions*
for *Drawing* & *Painting* them

according to NATURE :

Being a New Work intended
for the use & amusement of
Gentlemen and Ladies
Delighting in that Art.

LONDON.

*Printed for Robt. Sayer & Jno. Bennett,
No. 53 Fleet Street. Carr. Boales. No. 69 St. Pauls
Church Yard. Robt. Wilkinson No. 58 Cornhill.*

Price 6s. — & *Colour'd* 1l. 1s. 0d. —

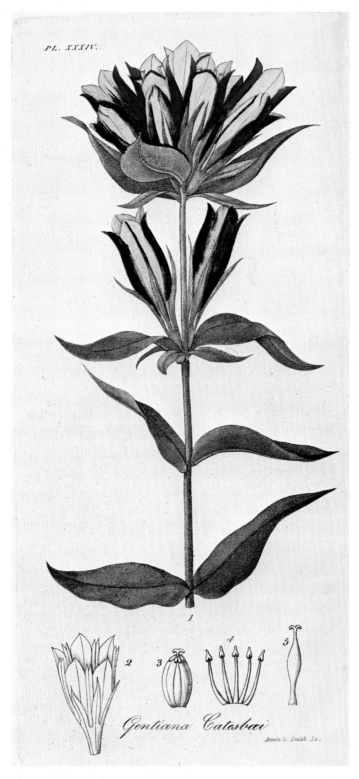

Gentiana Catesbæi

Annin & Smith Sc.

63

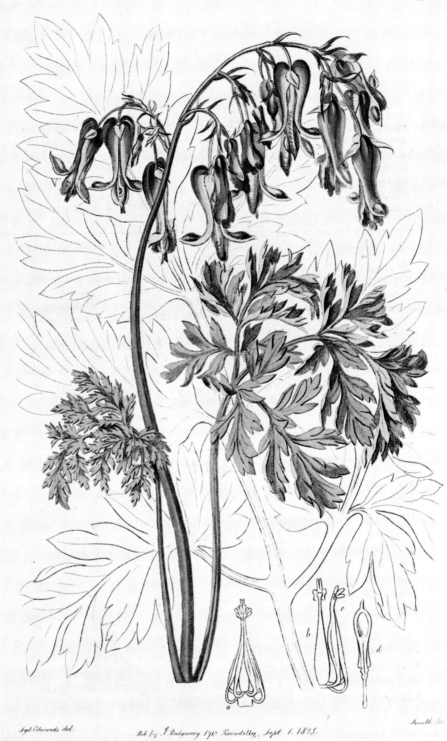

Pub. by J. Ridgway 170. Piccadilly, Sept. 1. 1815.

65. Wallflower *(Cheiranthus cheiri)*
FROM *The Florist*, BY R. SAYERS AND OTHERS, *c.* 1760

The flowers in *The Florist* were drawn from nature, and represented as 'ripened to a degree of Looseness, subject to be folded and play in the Wind'; and certainly the wallflower, normally a stiff plant, seems to be waving its leaves in a very animated manner. In the older writers it is the wallflower, not the pansy, that is given the name of heartsease, from its use in cardiac medicine. 'God send thee hart's ease . . . For it is moche better, with pouertie to haue the same, than to be a Kyng, with a miserable mynde . . . I praie God giue you but one handfull of heauenly hartsease: which passeth all the pleasaunt flowers that groweth in this worlde.' (1562)

66. Slipper Orchid *(Cypripedium venustum)*
FROM *The Botanical Cabinet*, BY G. LODDIGES, 1821

The enterprising firm of Loddiges was among the first to grow orchids for sale; they issued a comprehensive orchid catalogue in 1839 and by 1845 had over 1,900 species. Orchids from many sources are illustrated in the *Botanical Cabinet*, not all of Loddiges' own growing. This Old Glory of a flower, with its stars and stripes, had very recently been sent to Britain by Dr Wallich of the Calcutta Botanic Garden; it must have been one of the first plants he introduced. He had obtained it, probably by means of native plant-collectors, from the forbidden Kingdom of Nepal.

67. *Pelargonium inquinans* var. *niveo-unguiculatum*
FROM *Neu Arten von Pelargonien*, BY L. TRATTINNICK, 1825

Pelargonium inquinans and *P. zonale*, the two main ancestors of the 'geraniums' of today, were both introduced in the reign of Queen Anne. Other species of these South African plants quickly followed; most of them proved easy to grow and propagate, and to make good room and conservatory plants, and by the early nineteenth century the scale on which they were cultivated was truly astonishing. H. C. Andrews's volume on the Geraniums in 1805 was followed by Robert Sweet's *The Geraniaceae* in five volumes (1820–30) with 500 plates; and Trattinnick's book, also in five volumes (1825–31), with 202 plates was intended to supplement that of Sweet, with special reference to the varieties grown in Germany. But to the casual eye, the differences between these seven-hundred named sorts were not very great.

Even these works included no blue geraniums; but when the large genus was divided into three in 1787 it was the wild blue Crane's Bill of our northern meadows that retained the name of Geranium; the pink and red African species became Pelargoniums or Stork's Bills, and various charming little Alpines Erodiums or Heron's Bills—all having the stabbing beak of a seed-pod which prompted the original name.

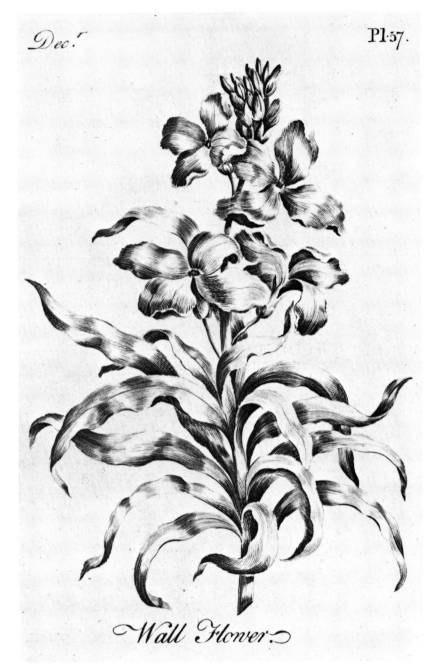

Wall Flower.

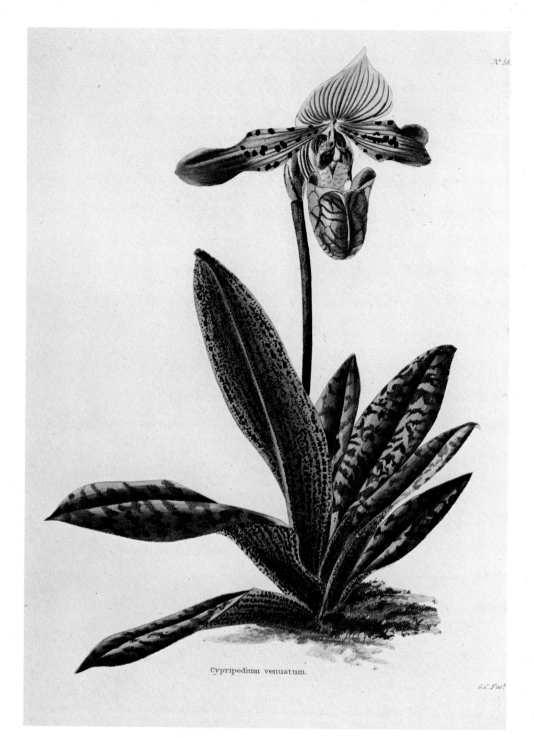

Cypripedium venustum.

G.C.Fec?

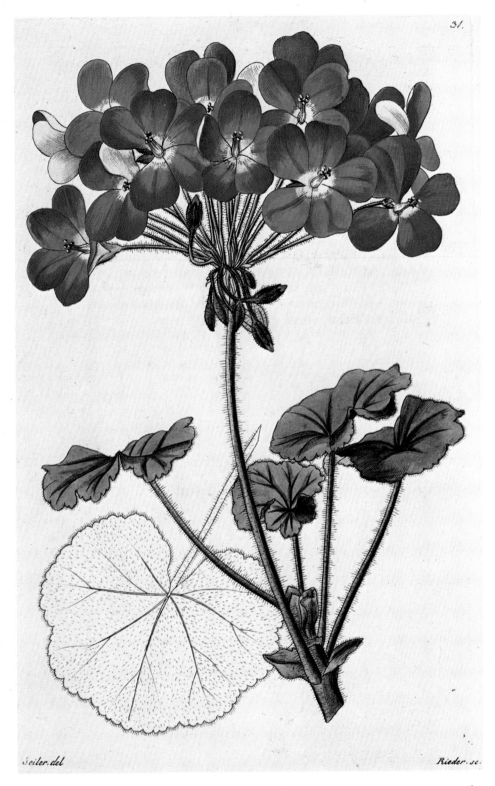

Seiler. del

Rieder. sc.

68. Poppy *(Papaver somniferum* var.)
FROM *The Florist*, BY R. SAYERS AND OTHERS, *c.* 1760

This flaunting poppy is of the kind that frequently appears in Dutch and Flemish flower-paintings. Elizabethan ladies dubbed it 'John Silver-pin, fair without and foul within' because of its offensive odour; but what else could be expected from a variety of the opium poppy? A warning smell *should* be provided by this useful but dangerous plant, which was once cultivated in England to make the laudanum or loddy 'so much used instead of tea by the poorer class of females in Manchester and other manufacturing towns'.

It is a curious fact that both in painting and book-illustration this flower is more often shown from the back or in profile (with its leaves and buds) than from the front—from van Spaendonck's magnificent folio *Fleurs Dessinées d'après Nature* to Charles Malo's tiny *Guirlande de Flore*. Perhaps the artists found the front-view shapeless.

69. Spring Adonis *(Adonis vernalis)*
FROM *Flora Conspicua*, BY R. MORRIS, 1825

One would expect Adonis to be closely associated with Anemone (see note to Plate 46) and sure enough, the genus belongs to the same family of the Ranunculaceae, coming half-way between the anemone and the buttercup. It is one of the mysteries of gardening why this handsome European perennial, which all agree to be of easy cultivation, should be so seldom grown. There is a British native or naturalized species, *Adonis annuus* or Pheasant's Eye, a cornfield weed with small scarlet flowers, to which Curtis in 1780 mysteriously refers as 'one of the plants which are annually cried about our streets, under the name of Red Marocco'. Why should street-vendors hawk a flower which had no recorded use, and whose decorative value is relatively small?

70. *Gladiolus cardinalis*
FROM *Flora Conspicua*, BY R. MORRIS, 1825

Almost nothing is known of the artist William Clark, but we must agree with John Lindley that his drawings in this book are 'real specimens of art' and can only regret that his output was so small.

At the time of publication several species of gladiolus had been introduced from South Africa, but hybridization had hardly yet begun. The first hybrids were raised by Dean Herbert about 1815, but his crosses did not reach the general public. About 1820, however, the nurseryman Colville crossed *G. cardinalis* with *G. tristis*, and produced the early-flowering race of *G.* × *colvillei*, some varieties of which are still grown; and in 1841 the first large-flowered gladiolus hybrid was raised by van Houtte from *G. cardinalis* × *G. psittacinus*. Since then this important species has fathered many fine flowers, but its descendants have lost the graceful bend in the neck which was characteristic of the parent.

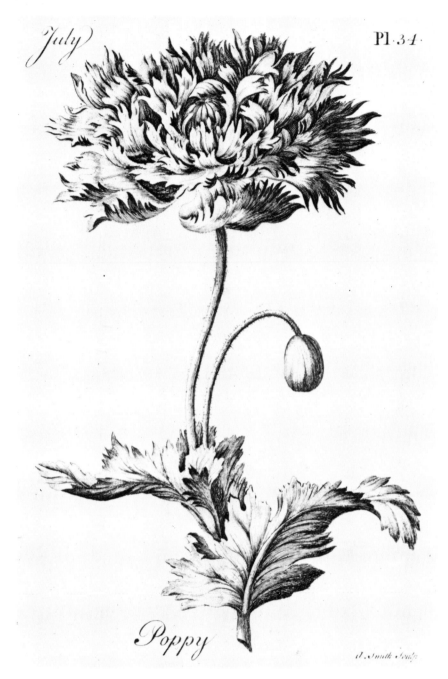

Poppy

d. Smith Sculp.

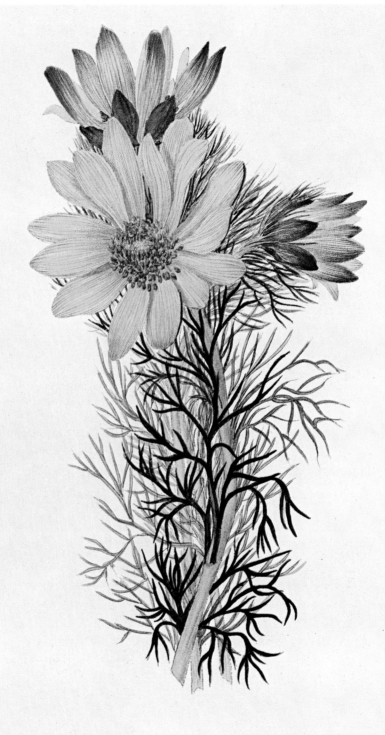

Drawn & Engraved by W. Clark.

69

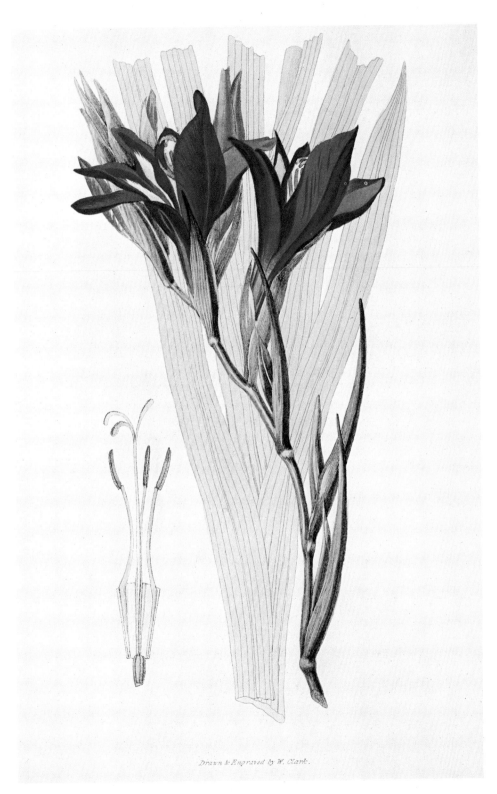

Drawn & Engraved by W. Clark.

70

71. Dead-Nettle *(Lamium album)*
FROM *Flora Rustica*, BY T. MARTYN, 1792

Thomas Martyn, a practising London physician, held the chair of botany at Cambridge, but rarely visited that city. His book on the plants and weeds of agriculture was illustrated by Frederick Polydore Nodder, Botanical Artist to Queen Charlotte—an improbable-sounding person who might have been invented by Lear or Lewis Carroll.

The dead-nettle is not a very harmful weed; it keeps to the hedgerows and competes little with the crops. Its flowers, said William Turner, 'have a strong savor, and are very like unto little coules, or hoodes, that stand over bare heades'. Its Somersetshire name was 'Adam and Eve in the Bower', because of the two black-and-gold stamens that lie inside the white hood. Dead-nettle, of course, means a nettle that does not sting; but in spite of the resemblance the plant is not botanically a nettle. It was formerly used to treat the king's evil.

72. Oleander *(Nerium oleander)*
FROM *Plantes de la France*, BY J. SAINT-HILAIRE, 1822

It is extraordinary that this splendid ten-volume work is so little renowned; possibly its neglect is due to the fact that it appeared at a time when many other fine flower-books, including those of Redouté, were being published. The subjects, which included both wild and garden flowers, were 'described and painted after Nature' by the author, and have been called 'exquisitely delicate plates of pure colour-printing, with no retouching by hand'.

This beautiful Mediterranean shrub, the Oleander, has been cultivated in gardens for centuries, though in Britain it requires some protection. Unfortunately it is extremely poisonous; William Turner, who had seen it in Italy, said (about 1551) 'I care not if it never com into England, seying it in all poyntes is lyke a Pharessy [pharisee] that is beuteus without, and within a ravenus wolf and murderer.' Yet both rose and white varieties were introduced before thirty years were out.

73. Buck's-Horn Plantain *(Plantago coronopus)*
FROM *Plantes de la France*, BY J. SAINT-HILAIRE, 1822

Because it has no colour, this plant is not thought to be ornamental; but every drawing of it, from the herbals to *Flora Graeca*, reveals how satisfying is its design. It is one of our nine British species, but it was the Broad-Leaved Plantain *(P. major)* that was so highly valued for its medicinal properties, chiefly as a wound-herb; its use went back to Anglo-Saxon times. Gardeners who grow ferns and hostas for their foliage might consider the merits of this plantain, especially for a poor place such as the edge of a gravel path; but probably it would be impossible to stop zealous helpers from weeding it up. It is a maritime plant, and said to be excessively variable.

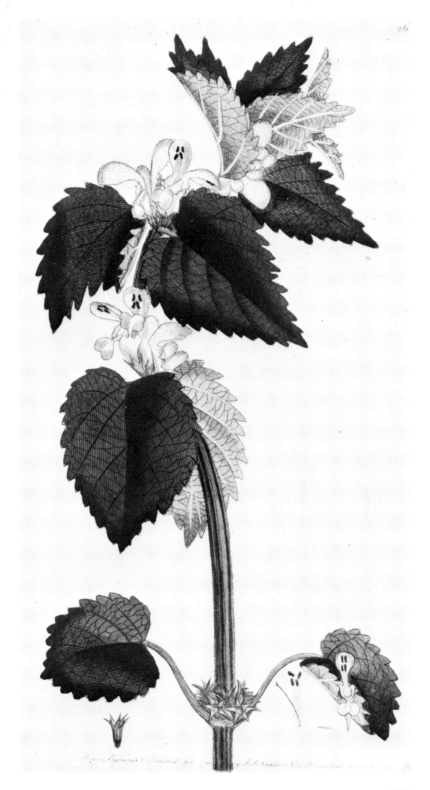

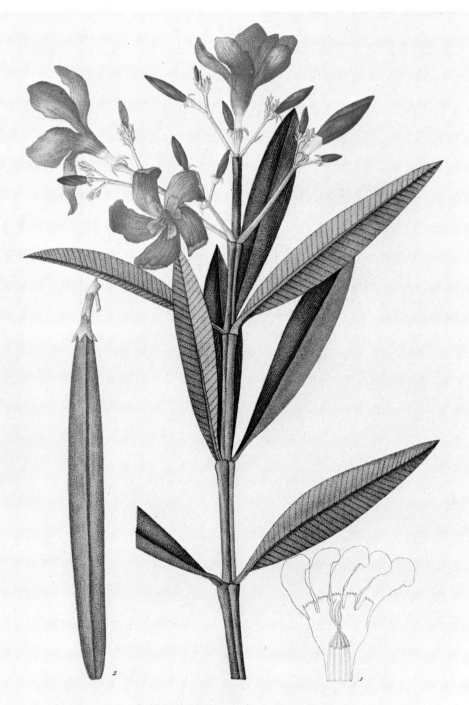

LAUROSE DES JARDINS.

502.

72

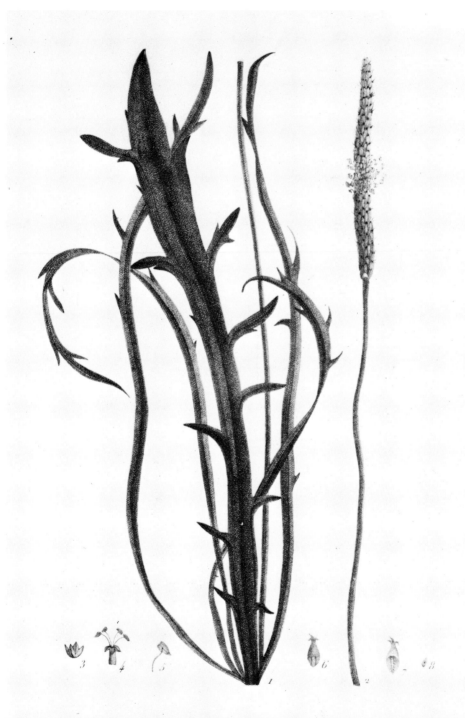

PLANTAIN CORNE DE CERF. 304.

74. Silk Grass (*Yucca filamentosa*)
FROM *Dreyhundert Auserlesene Americanische Gewächse*, BY J. ZORN, 1786

Johann Zorn, apothecary, seems to have been an industrious compiler rather than an original author; his name does not appear on the title-page of his books and his editorship is deduced only from internal evidence. Over 250 of his 'Three Hundred Selected American Plants' are reduced copies of plates from Jacquin's *Selectarum stirpium Americanarum Historia* (1763); the remainder are by no means exclusively American, but include some familiar Mediterranean and South African species.

The American *Yucca filamentosa* was not new to Europe; it had bloomed in England in 1675. The fibres produced from its leaves were formerly used by the Indians to make cloth and cordage. Like all yuccas, it looks its best by moonlight—indeed, it is said to delay its blooming till the moon is full. This may be true, but if so, the timing is dictated by the habits of its special pollinating moth, without whose services it cannot set seed.

75. Sparrow and Iris (*Passerella iliaca iliaca* and *Iris verna*)
ORIGINAL DRAWING BY WILLIAM BARTRAM, *c.* 1768

William Bartram, son of America's great pioneer plant-hunter John Bartram, was a zoological rather than a botanical artist, but he could draw flowers well, though they were not his first choice. His 'low spring sweet iris' of North Carolina was *I. verna*, sometimes called the Violet Iris from its colour and sweet scent. A specimen and drawing of it had been sent to England by the Virginia naturalist John Banister in 1688, but living plants were not introduced till 1748. Though still grown in rock-gardens, it is not very widely cultivated, perhaps crowded out by competitors from all over the northern hemisphere; there are so many small irises that only the best can survive. The greedy-looking bird is the Eastern Fox-Sparrow.

76. Indian Physic (*Gillenia trifoliata*)
FROM *American Medical Botany*, BY J. BIGELOW, 1820

This plant was sent from Virginia by the Reverend Charles Banister to Henry Compton, Bishop of London, before 1690, and was successfully cultivated by Compton's gardener, William Milward. By 1713 it was to be seen in 'several curious gardens about London', but though possessed of every garden virtue, it is still uncommon. At the time of its introduction, much discussion took place as to whether this 'Indian Physic' was the source of the drug ipecacuanha (actually from Brazil)—it had similar, though milder, emetic and purgative properties. Curiously, André Michaux in 1794 found it was called Papiconah 'by the Savages and the Illinois French' as though the English name of Virginia Ipecacuanha had got translated back to American . . .

> *Coughing in a shady grove*
> *Sat my Juliana.*
> *Lozenges I gave my love—*
> *Ipecacuanha . . .*

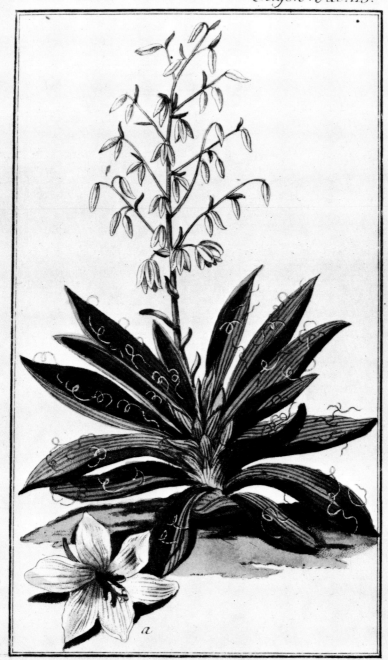

a

Yucca filamentoſa . L.

74

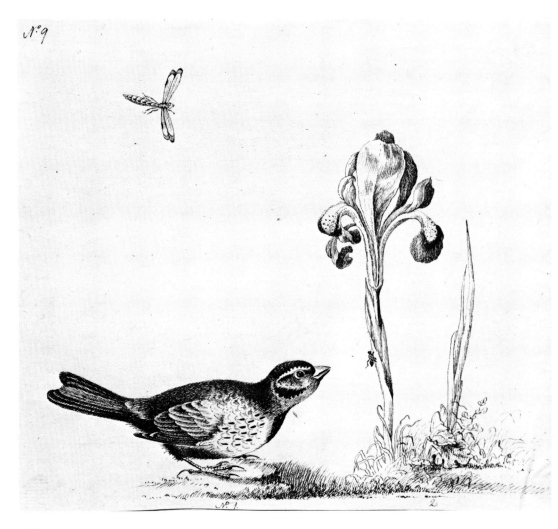

N.º 1.

2.

Pl. XLI

Gillenia trifoliata

77. *Stokesia cyanea*
FROM *Hortus Kewensis*, BY J. HILL, 1769

The *Hortus Kewensis* to which botanists so often refer is usually that published by the reliable William Aiton in 1789; but there was an earlier one, produced in 1769 by that eccentric and versatile character John Hill, a protégé of Kew's founder, Lord Bute. It is a straightforward list of the species grown, and although the garden had only been established for eight years, they already numbered 3,400. Those thought new are briefly described in Latin, and twenty of these new species are illustrated. The plates are unsigned.

This shaggy-dog American cornflower, sometimes misleadingly called Stoke's Aster, has never become a really familiar garden flower. All authorities agree that it is handsome, but differ as to whether it is hardy; blooming, as it does, late in the year, it does not always expand its flowers fully, unless given some protection.

Hill's name of 'Carthamus' was changed by the French botanist L'Heritier, who visited London in 1786–7, and named several new genera after British botanists in compliment to his English hosts. Dr Jonathan Stokes, a provincial amateur, had recently helped Dr William Withering to prepare an improved second edition of his *Botanical Arrangement of British Plants*, which was published during L'Heritier's visit. Stokes was disapprovingly described as 'a worthy and ingenious man, but a dissenter, and consequently a democrat'.

78. 'Genista' (Cytisus) striata
FROM *Hortus Kewensis*, BY J. HILL, 1769

It is hardly surprising that this slender little broom from Spain and Portugal should have been overlooked by botanists before Hill's time; it has been overlooked by gardeners ever since, for it is not in cultivation. The very similar genera of Genista and Cytisus, according to the botanists, are distinguished only by the presence or absence of a strophiole or protuberance on the seed, which the former has and the latter has not; so Hill's plant is now classed as a Cytisus. But nobody really knows of just what species was the Planta Genista, the snatched flower worn as a plume in battle that became the badge of the Plantagenets.

79. *Nerine undulata*
FROM *Hortus Kewensis*, BY J. HILL, 1769

Nerine undulata is one of the parents of the race of greenhouse hybrid Nerines. The first crosses were made by Dean Herbert in 1815, and it was he who separated the genus from Amaryllis and named it Nerine, in reference to the romantic but unreliable story that the Guernsey Lily, *N. sarniensis*, was found growing in the sands of Guernsey, having been washed ashore from a wreck. (The fifty Nereides or mermaids, whose name means 'the wet ones', were daughters of the sea-god Nereus.) 'Undulata' refers to the Marcel-waved petals, even more curly than those of most Nerines, and obviously designed to withstand the effects of salt water.

Carthamus Lævis.

Genista Striata.

Amaryllis
Undulata.

80. *Oxytropis uralensis*
FROM *Flora Scotica*, BY J. LIGHTFOOT, 1777

This little book was the result of a tour of Scotland and the Hebrides made by the Reverend John Lightfoot in company with the zoologist Thomas Pennant in 1772, the year before James Boswell and Dr Johnson made a similar tour. With the help of Scottish correspondents Lightfoot compiled a flora of some 1,200 species, including mosses and seaweeds; Pennant paid for its publication and contributed a somewhat incongruous preliminary section on Scottish mammals (living or extinct), birds and fishes.

In November 1777 Lightfoot wrote indignantly to Sir Joseph Banks about a review of his book in which he was accused of copying his illustrations from other botanists. The plate of *Astragalus uralensis* (=*Oxytropis uralensis*) was particularly mentioned, whereas Banks could testify that the reviewers were 'damnable liars' since the plate and drawing had been made from Lightfoot's own specimen and given to him by Banks. The subject, a 'humble, but very pleasing plant' rare in cultivation, was found growing alongside *Dryas octopetala* (see Plate 106).

81. Convolvulus, Bindweed *(Calystegia sepium)*
FROM *Abridgement to the Flora Londinensis*, BY W. CURTIS, 1792–3

The great pure trumpets of this most pernicious weed are beautiful, if perhaps a little over-simplified in design. 'There is a flower', says Gerard, quoting Pliny, 'not unlike to the Lillie . . . growing among shrubs, without smell, without yellow chives within, onely representing a white colour, and as it were a rude shape of nature, as now going about to learn how to make Lillies.'

This 'abridged' edition of the *Flora Londinensis* ran only to three dozen plates, unsigned except by the engraver, Sansom. Though reduced in size, they were little inferior in quality to the folio originals. The book is rare, and the reproductions were made from an incomplete and uncoloured copy, which shows all the better the fine quality of the engraving, so often obscured by the colours.

82. Marsh Marigold *(Caltha palustris)*
FROM *Abridgement to the Flora Londinensis*, BY W. CURTIS, 1792–3

'It-opens-the-swamps' was the Onandaga Indian name for this marigold, and in cold Northern countries such as Iceland it is one of the first flowers of spring. In New England its leaves were among those eaten as 'spring greens' though the plant belongs to a dangerous family, several of whose members are poisonous. Many young feet have got wet when their owners gathered the 'Drunkards' (another of the plant's apt names) and double forms have been cultivated in gardens since one was found near Salzburg, before 1601, and taken to Vienna to give pleasure to the ladies of the Court. Dr Withering says that when marsh-marigolds were taken into the bedroom of a young girl subject to fits, the attacks ceased; but whether this was truly cause and effect has not been satisfactorily established.

Gab.\ Smith fec.\

Astragalus
uralensis. P. 401.

Convolvulus
sepium

Pub.ᵈ by W. Curtis Sᵗ Geo. Crescent Apr. 16. 1792 Sanfom Sculp

81

Caltha
palustris.

Pub. by W. Curtis S.ᵗ Geo: Crefcent May 1. 1792

Sanfom Sculp.

82

83. *Onosma echinata*

FROM *Flora Atlantica*, BY R. DESFONTAINES, 1799

In Latin—the official, not the sentimental, language of flowers—*Onosma echinata* means a scentless flower with spines like a hedgehog; while its similar-sounding cousin *Onosma echioides* means 'resembling the Echium' or Viper's Bugloss. The latter species has a yellow flower with brown spots at the base of each of the five petals which disappear as the flower ages and are said to have been made by the dirty fingertips of Mohammed. This 'Prophet Flower' is in cultivation, but *O. echinata* has nothing to recommend it except its extreme bristliness—like the Old Man of Bavaria, 'You never saw anything hairier!'—and Mohammed passed it by.

The drawing is an example of Redouté's purely botanical work, so little known in comparison with his coloured flower-pictures.

84. *Calceolaria nana*

FROM *Plantarum Icones Hactenus Ineditae*, BY J. E. SMITH, 1789–91

When Charles Darwin visited the Strait of Magellan in 1831 in the course of his voyage in the *Beagle*, he found the natives among the most primitive on earth; wearing paint and very little else, living miserably on raw shellfish, and sleeping in the rain on the bare ground, in 'forms' like those of a hare. This little calceolaria from the same region seems to reflect in its aspect all the stupid savagery of these primitive tribes. A closely allied species found by Darwin *(C. darwinii)* is a favourite with rock-gardeners, though it is difficult to grow; but *C. nana* itself is not in cultivation. The first calceolaria ever to be introduced *(C. fothergillii, 1777)* came from Patagonia and the Falkland Islands; it is said to be hardy, but the tender species from the tropics actually seem more amenable to horticulture.

85. Persian Iris *(Iris persica)*

FROM *The Botanical Magazine*, ED. W. CURTIS, 1787

This plate was a portent—the first plate of Curtis's momentous *Botanical Magazine*; and without going so far as the authority who called it 'one of the most delightful flower-pictures ever issued', it is sufficiently attractive to make one regret that its subject is now rarely seen. Before the introduction of *Iris reticulata* and *I. histrioides*, *I. persica* was the most valued of all the dwarf bulbous irises, and bulbs were annually imported from Holland to be grown in pots. Curtis said that it would 'blow within-doors in a water-glass' and that a few of its flowers would scent a whole room; but in the garden it required warmth and shelter. Perhaps it was the 'Persian Iris' that was planted by the hundred in the gardens of the newly built Blenheim Palace in the reign of Queen Anne; but Parkinson in 1629 did not find it easy to grow, nor do the gardeners of today.

P. J. Redouté Sellier Sc.

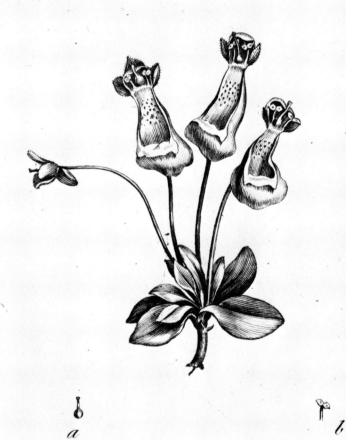

a

b

Calceolaria nana.

84

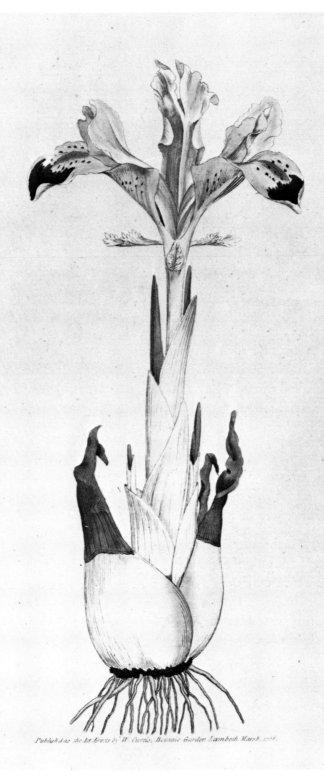

Publish'd as the Act directs by W. Curtis, Botanic Garden Lambeth Marsh. 1786.

86. Bluebell, Wild Hyacinth *(Endymion non-scriptus)*
FROM *English Botany*, BY J. SOWERBY, 1797

Botanists, having decided that the bluebell was neither a scilla nor a hyacinth, gave it the lovely name of Endymion, after Diana's lover—only half-appropriately, as it is a woodland but not a moonlight flower.

It used to be considered polite manners for a courtier to stand with his weight on one leg and the other knee slightly flexed. The bluebell is like that—sturdily upright, yet at the same time gracefully drooping. The poet Gerard Manley Hopkins, who wrote of 'a juicy and jostling shock/Of bluebells sheaved in May', was also the first to observe that in a bluebell-wood nearly all of the thousands of heads bend in the same direction.

87. Dropwort *(Spiraea filipendula)*
FROM *English Botany*, BY J. SOWERBY, 1795

Dropwort is closely allied to meadowsweet, and in its double form makes an excellent garden-plant, its coral buds opening to lasting creamy-white flowers. William Robinson made the heartless suggestion that it should be grown as an edging-plant for its leaves alone, and not allowed to bloom. Meadowsweet is a waterside plant, but the dropwort seems to prefer dry uplands, and has not the meadowsweet's heavy scent nor its various uses. It got its name both in English and Latin ('filipendula'—hanging by a thread) from the roundish tubers which depend at intervals from its thin roots; but this peculiarity does not seem to have suggested to our ancestors (usually so fertile in such expedients) any appropriate medical use.

88. Wood Star-of-Bethlehem *(Ornithogalum nutans)*
FROM *English Botany*, BY J. SOWERBY, 1809

In Britain this flower is a naturalized alien, growing wild in a limited area of East Anglia. The green stripe on the back of each segment of the flower comes through to the front as a silver-grey, a colour most unusual in flowers, and the intricate structure of the creamy centre makes this quiet bloom well worth a second look. Though so quakerish and demure it can become invasive if the soil suits it, and gardeners have been known to cart away with curses barrow-loads of bulbs for which other gardeners would sigh in vain. The name of Star-of-Bethlehem properly belongs to a related species, *O. umbellatum*.

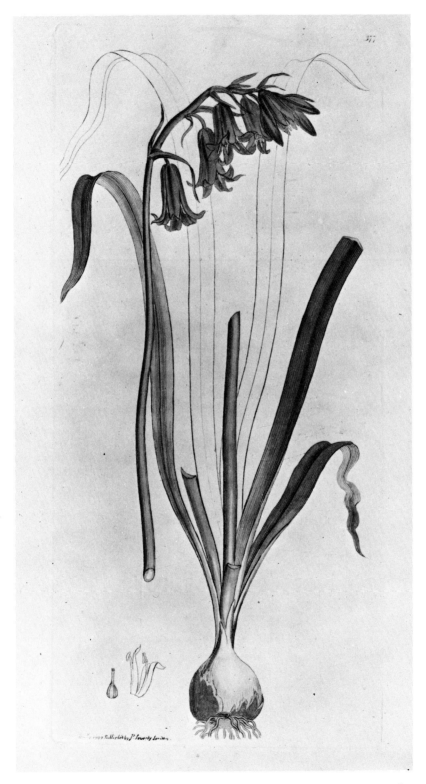

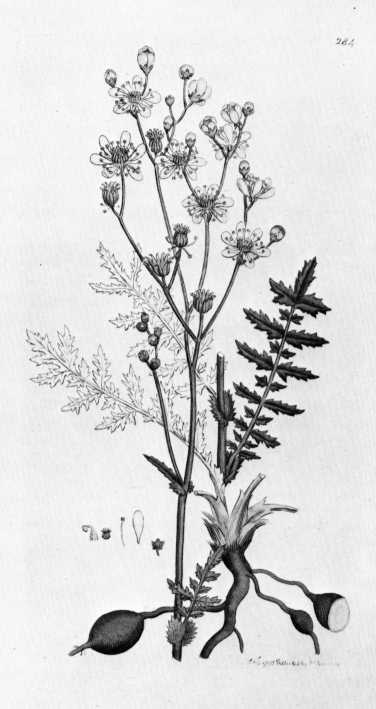

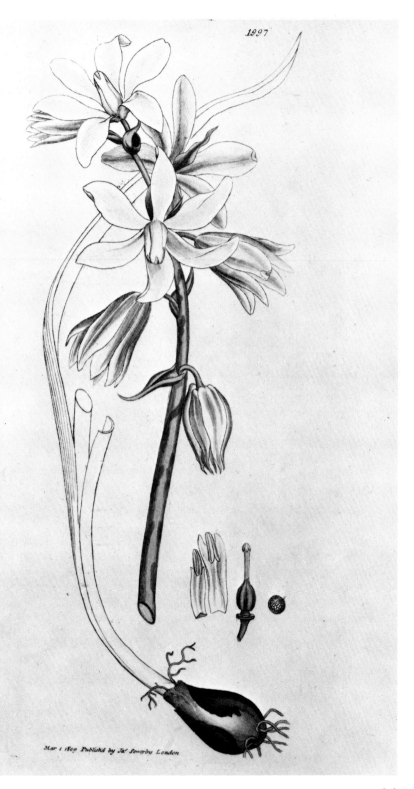

1997

Mar 1 1809 Publish'd by Ja.ʳ Sowerby London

88

89. Lady's Mantle *(Alchemilla vulgaris)*
FROM *Flora Bedfordiensis*, BY C. ABBOT, 1798

Seventeen ninety-eight was a relatively early date for the publication of a regional flora; but the Reverend Charles Abbot was a real enthusiast, who transplanted many of the plants he found into his garden, in order to study them the better. His little book, dedicated to Queen Charlotte, was illustrated by all of six colour-plates, three of them of fungi. They are unsigned, and might have been the work of a 'fair associate' to whom he pays tribute in the preface; she cultivated his garden, prepared his herbarium, and laid him under 'innumerable' other obligations. (Abbot was a great champion of the female botanist.)

Most botanists have a favourite flower; and although the Lady's Mantle was neither new nor rare—Turner in 1548 remarked that 'It groweth in middowes like a Mallowe'—Abbot thought it 'of all our natives . . . the most elegant plant'.

90. 'Dalibarda' *(=Waldsteinia) fragarioides*
FROM *Flora Boreali Americana*, BY A. MICHAUX, 1803

After spending eleven exhausting years exploring the flora of North America on behalf of his country, André Michaux returned to post-revolutionary France; he was received with honour, but little of his seven years' overdue salary was repaid. In 1800 he joined Captain Nicolas Baudin's scientific expedition to Australia (see note to Plate 100), leaving the publication of his book to his son François, who was 'little versed in botany', and it appeared a year after its author's death in Mauritius. Although a modest production it was of great importance as the first comprehensive flora of as much of the North American Continent as was then known. The plates, by Redouté, are printed on paper slightly smaller than that of the text, and are difficult to find.

It hardly seems to matter what are the subjects of these elfin drawings, which look as though they had been engraved with the sting of a wasp. *Dalibarda fragarioides*, a yellow flower allied to the brambles, was once fairly well known in Britain, judging by the fact that it appears in two of the botanical periodicals, in 1818 and 1820. It was later removed to a small genus named after an Austrian botanist, Count Franz Adam Waldstein-Wartenburg.

91. *Lespedeza procumbens*
FROM *Flora Boreali Americana*, BY A. MICHAUX, 1803

There are quite a number of Lespedeza species, some of which are cultivated for fodder or green-manuring, though the little violet *L. procumbens* does not look as if it would nourish a newt. Like the Dalibarda, this fragile wild flower has been in cultivation in Britain, but neither can be called familiar. It was named by Michaux in honour of Señor D. Lespedez, a Spanish governor of Florida, a country which he visited in the course of his botanical travels.

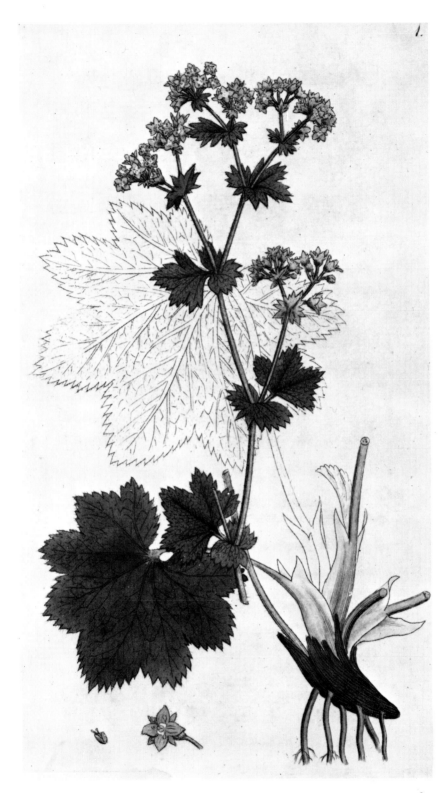

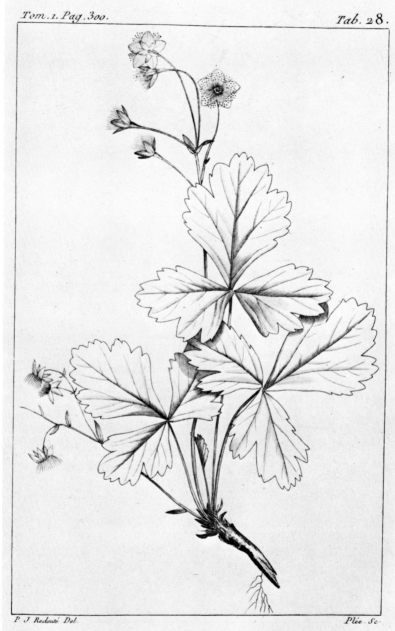

P. J. Redouté Del. *Plée Sc.*

DALIBARDA *fragarioides.*

90

P. J. Redouté Del. Plée Sc.

LESPEDEZA *procumbens.*

91

92. *Rubus spectabilis*
FROM *Flora Americae Septentrionalis*, BY F. PURSH, 1814

The German botanist Frederick Pursh emigrated to America in 1799 and worked for Dr B. S. Barton of Philadelphia, and then for Dr Hosack of New York. On the outbreak of war between Britain and America in 1812 he came to England. He was kindly received by British botanists, who helped him to produce this book—the most important flora of North America since that of Michaux, though still only in two small volumes, with twenty-four plates by William Hooker.

Rubus spectabilis was afterwards (1827) introduced to the Horticultural Society by David Douglas, but disappointed the expectations aroused by Pursh's plate and description. Probably it is better in the wild. The German botanist G. W. Steller was very enthusiastic about it when he found it on his one-day visit to Alaska during Captain Bering's expedition from Kamchatka in 1741. He dug up plants which he hoped to send to St Petersburg, but owing to the misfortunes that afterwards beset the voyage, they did not survive.

93. 'Bletia hyacinthina' (Bletilla striata)
FROM *The Botanical Cabinet*, BY G. LODDIGES, 1833

Here is another of Loddiges' orchids (see Plate 66)—this time from China, and so nearly hardy that it is listed in bulb-catalogues, and venturesome gardeners try to grow it out-of-doors. 'The colour of this flower baffles art more than many others,' wrote Loddiges, 'its clearness and brilliance in the living specimen being absolutely inimitable'; and it is true that even with modern chemical pigments its particular shade of bright magenta is hard to reproduce. It was introduced in 1802 by William Kerr, the collector sent to Canton by Sir Joseph Banks to obtain plants for Kew, and must be regarded as one of his greatest prizes.

94. Wintergreen (Gaultheria procumbens)
FROM *The Botanical Cabinet*, BY G. LODDIGES, 1818

In 1747 the Swedish Government sent Peter Kalm to explore the flora of North America, hoping that he might find plants of economic value that would grow in Sweden. Kalm's travels took him as far north as Quebec, where he was welcomed by the Governor, the Marquis de la Galissonière, and his physician, Dr J. F. Gaulthier. The Marquis and the doctor were attempting to compile a flora of Canada, but the latter died and the former was recalled to France before it was completed. Dr Gaulthier had conducted Kalm to all the places of interest in and about the city, and in return Linnaeus, at Kalm's request, named after the doctor this medicinal plant, source of the Oil of Wintergreen formerly much used to alleviate rheumatism. It is also cherished by many non-rheumatic rock-gardeners.

This is one of the six plates contributed to the *Botanical Cabinet* by a Miss Rubello, from whose 'skilful pencil' George Loddiges expected 'valuable assistance'. But after the fifth of the twenty volumes she appears no more.

Tab. 10. p.

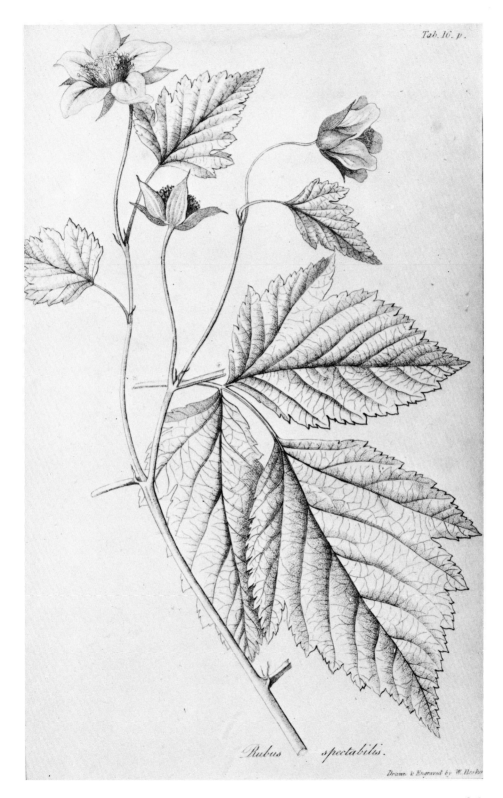

Rubus spectabilis.

Drawn & Engraved by W. Hooker

G. Loddiges del. Bletia Hyacinthina

93

Gaultheria procumbens.

Drawn by Miss Rebello. G. Cooke Sc.

94

95. Pallas's Oxlip *(Primula elatior* subsp. *pallasii)*

FROM *Monographia Generis Primularum*, BY J. G. C. LEHMANN, 1817

Lehmann named this flower *Primula pallasii*, but it is now classed as a subspecies of *P. elatior*, the oxlip, which grows wild in some of England's eastern counties, but which must not be confused with the commoner primrose-cowslip hybrid *(P.* × *variabilis)*, which is the parent of the polyanthus. Most of the primulas are regrettably promiscuous, and even the aristocratic oxlip will only keep its stock pure if it is not tempted. The distinct variety *pallasii* is found in the Urals, which the botanist Peter Simon Pallas explored in 1769–70, and in the Caucasus, which he visited in the autumn of 1793. The plate looks like a wash drawing, but is actually an incredibly fine stipple-engraving shaded by the roulette—a wheel studded with tiny points by which dots can be made on the copperplate more finely and closely than by hand.

96. Harebell *(Campanula rotundifolia)*

FROM *The Moral of Flowers*, BY MRS HEY, 1835

Mrs Hey presents us with a curious mixture of botany, horticulture, plant-lore and uplifting verse; but a flower-picture is a flower-picture even when it illuminates a text, and especially when it is drawn, as here, by the accomplished William Clark. The 'moral' of this figure was 'all flesh is grass, and the goodliness thereof is as the flower of the field'.

Evidently the authoress was not aware of the sinister associations of the harebell, which in some places is called Witch Bell, Witches' Thimble, or Auld Man's Bell, and is never picked. The hare, too, is a witch-animal; though some render the name as hair-bell, because of the extreme slenderness of its stems. Linnaeus named the plant *rotundifolia* (round-leaved) from the winter rosette of rounded root-leaves, which he found growing on the steps of the university at Upsala; but when it stretches itself to flower, the stem-leaves become narrow and linear.

97. Persian Rose *(Rosa persica)*

FROM *The Botanical Register*, ED. J. LINDLEY, 1829

This romantic flower was found by André Michaux in the deserts of Shiraz and introduced to Paris on his return from Persia in 1785. Later, it was found to be so abundant on Mt Elwand that it was used by the donkey-load for fuel all over northern Persia. Ever since its discovery this plant has given a great deal of trouble—to botanists, who cannot decide whether or not it is truly a rose (hence 'Lowea' and other synonyms), and to gardeners, who find it about as tractable as an untamed tiger. 'It resists cultivation in a remarkable manner,' wrote Lindley. 'Drought does not suit it, it does not thrive in wet; heat has no beneficial effect, cold no prejudicial influence; care does not improve it, neglect does not injure it.' Few plants, raised from seed, survived their first flowering.

Men say there blows in stony deserts still a rose
But with no scarlet to her leaf, and from whose heart no perfume flows.

Primula Pallasii

95

96

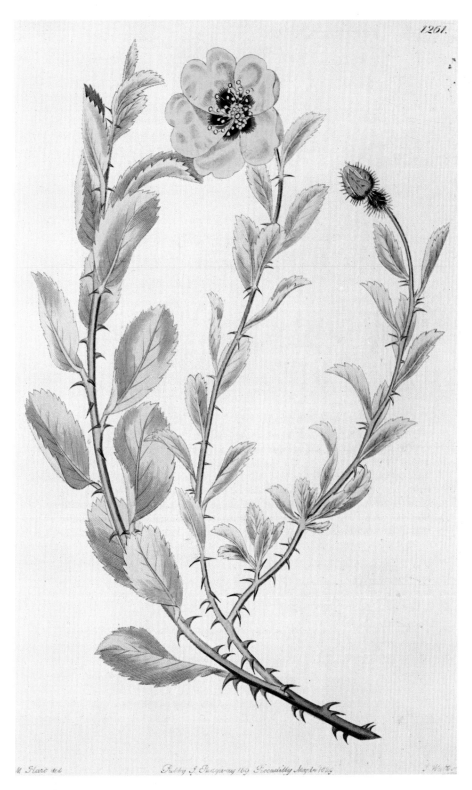

M. Hart del. Pub.by J. Ridgway 169 Piccadilly May.1.1844 J. Watts.

98. *Helianthemum tuberaria*

FROM *The Cistinae*, BY R. SWEET, 1825–30

Probably it would be impossible today to find more than a fraction of the 112 cistuses, helianthemums and halimiums described by Sweet, many drawn from the Chelsea Physic Garden and the rest from nurseries and private gardens about London. It was something of a feat for E. D. Smith to illustrate so many, since most of the fugitive flowers in this genus open only in the morning—and in sunshine—and are over by midday; this, and the slight tenderness of many of the species, may account for their present neglect.

H. tuberaria is one of the few herbaceous species in this predominantly shrubby genus. According to Parkinson it received its name of 'tuberaria' from 'those Spanish or outlandish puffs that are edible or fit to be eaten, because where that shrub groweth they usually finde those puffes do breede'—an ancient and delightful way of detecting the elusive truffle.

In 1824 Sweet was tried at the Old Bailey for feloniously receiving seven plants stolen from Kew; fortunately he was acquitted, or he might have been given the opportunity of observing his favourite Australian plants at Botany Bay. In 1831, with twelve books to his credit, he contracted brain-fever; he never completely recovered, and died insane.

99. Four flowers (*Ribes aureum, Phlox nivalis, Anemone hortensis* and *Scilla siberica*)

FROM *The Botanic Garden*, BY BENJAMIN MAUND, 1827–8

This periodical was issued in monthly parts and amounted eventually to thirteen volumes, each containing nineteen plates showing four plants apiece—a staggering total of 988 neat, pretty pictures of flowers.

The Golden or Buffalo Currant (*Ribes aureum*) was introduced from America in 1812, more than a dozen years before its red-flowered cousin, *R. coccineum*; but although it is of the easiest culture, it never attained the latter's widespread popularity. *Phlox nivalis*, from South Carolina, was introduced to Britain by John Fraser in 1788. Two varieties of *Anemone hortensis* were grown by Gerard in 1597; it is one of the progenitors of the generally mixed race of garden anemones, but the true species is rarely seen in cultivation. *Scilla siberica* was a comparative late-comer, not cultivated till 1796 and still regarded as something of a novelty.

100. *Kennedya coccinea*

FROM *Flora Australasica*, BY ROBERT SWEET, 1827–8

After several postponements, Captain Nicolas Baudin left France in October 1800 for an exploring expedition to Australia, carrying a shipload of quarrelling scientists, most of whom fell conveniently ill at Mauritius and abandoned the voyage. The expedition on the whole was unfortunate, and Baudin himself died at Mauritius on the way home; but seeds and living plants collected by his staff were brought safely back to France and were cultivated by the Empress Joséphine in her garden at Malmaison. When the present subject flowered, it was found to be of a new genus, and was named by Joséphine's botanist, Ventenat, in honour of an English nurseryman, the 'celebre cultivateur' John Kennedy, a partner in the famous firm of Lee and Kennedy, with which Joséphine had much to do.

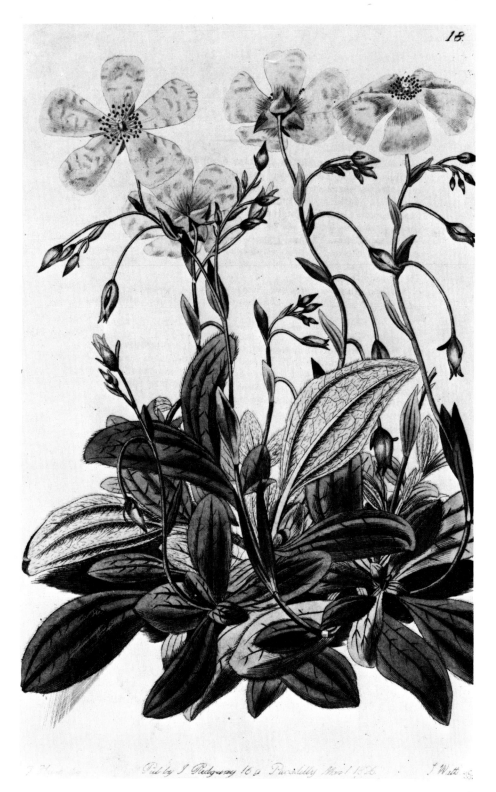

Pub by J Ridgway 16 g Piccadilly Mar 1 1826

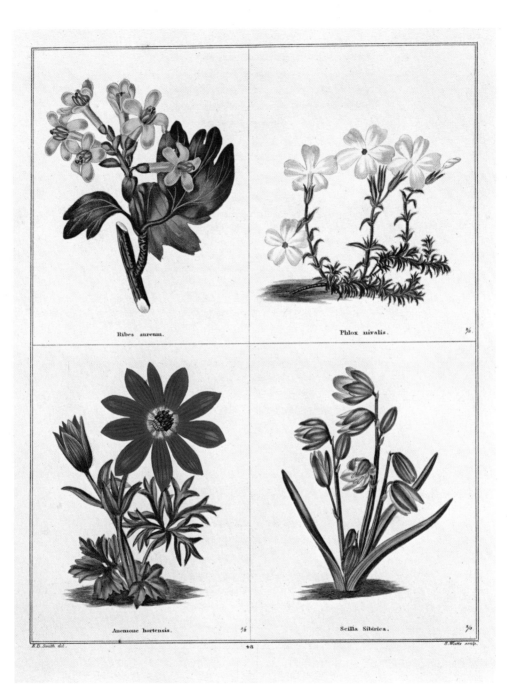

Ribes aureum.

Phlox nivalis. ⅔

Anemone hortensis. ⅖

Scilla Sibirica. ⅗

R.D.Smith del. S.Watts sculp.

48

99

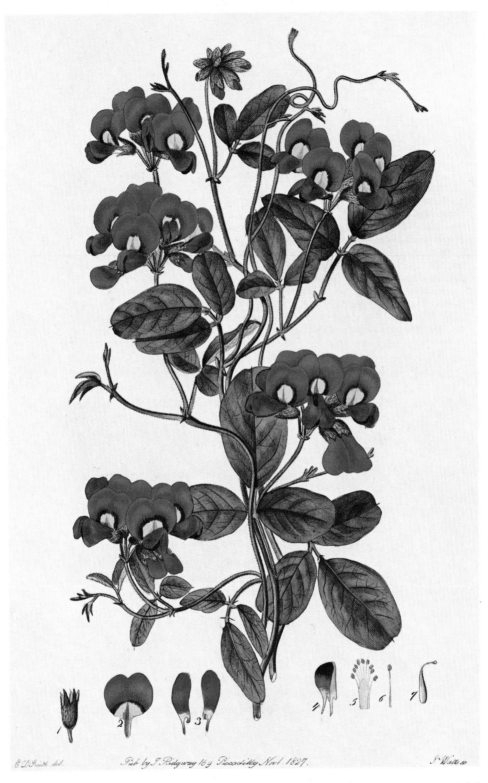

E. D. Smith del.　　　Pub by J. Ridgway 169 Piccadilly Nov. 1. 1827.　　　J. Watts sc.

101. Honeycups *(Dryandra longifolia)*
FROM *Flora Australasica*, BY ROBERT SWEET, 1827–8

When Sir Joseph Banks went round the world with Captain Cook and explored so much of the flora of Australia, he was accompanied by the Swedish botanist Solander, who afterwards became his librarian. Solander died rather suddenly in 1782, and was succeeded by another Swede, Jonas Dryander. He in turn was followed by Robert Brown, who had himself circumnavigated Australia with Captain Flinders. Brown named this new Australian genus 'with peculiar pleasure' after his predecessor, because it was very closely allied to Banksia—'this is as it ought to be,' he wrote, 'that Dryandra should have the nearest affinity to Banksia.' (Altogether, a cosy family affair.) Dryandras are showy cool-greenhouse plants, once popular but now neglected.

102. *Crocus imperati*
ORIGINAL WATERCOLOUR BY W. HERBERT, BEFORE 1847

The Honourable and Reverend William Herbert, Dean of Manchester, was a very remarkable man, and botany was only one of his many accomplishments. He was an excellent draughtsman, and as a horticulturist was the first to make controlled scientific experiments in the hybridization of plants. After a prolonged study of the family of the Amaryllidaceae he turned his attention to the Iridaceae, and his masterly tract on the genus Crocus was published shortly after his death.

Although common in every hedgebank south of Naples, *Crocus imperati* seems to have been overlooked till 1826, when it was named by Professor Tenore of Naples. It was introduced to England by Mrs Bury Palliser, who travelled on the Continent from 1830 to 1832, and sent or brought many plants to her flower-loving mother, Mrs Marryat of Wimbledon, just at the time when her ebullient brother Frederick was embarking on his successful career as a writer of sea-stories. She probably obtained it, as she did other plants, from Professor Tenore himself.

103. Christmas Rose *(Helleborus niger)*
FROM *Medical Botany*, BY J. STEPHENSON AND J. M. CHURCHILL, 1831

Having been successfully used by the physician Melampus to dose the demented daughters of King Proetus of Argos (about 900 B.C.), hellebore acquired a tremendous reputation as a cure for insanity. Unfortunately it is not clear which species Melampus used, as several hellebores are found in Greece, and they do not necessarily share the same properties. It was certainly not *Helleborus niger*, which is a native of the Carpathians and does not grow in Argos; but it was to this spectacular and long-cultivated flower that the legends and medical uses were eventually transferred. It was still used officially in the late eighteenth century—among other things to kill worms; but it was a dangerous remedy, which as often as not killed the patient as well.

After the stamens and nectaries of the flower have fallen the calyx persists and gradually turns a green or pinkish colour—to the disapproval of Erasmus Darwin:

> *Each roseate feature turns to livid green,*
> *Disgust, with brow averted, shuns the scene.*

E. D. Smith ad. Pub. by I. Ridgway 169 Piccadilly June 1. 1827. I. Watts sc.

W. Herbert d.

Helleborus niger.

104. Canadian Columbine *(Aquilegia canadensis)*
FROM *Flora Conspicua*, BY R. MORRIS, 1825

In the Language of Flowers the columbine stands for Folly, as it was supposed to resemble the jester's cap and bells; and nowhere is this symbolism so delightfully expressed as in this drawing by William Clark, in which flowers and leaves seem to dance until its bells jingle. This American columbine was an early discovery, and often appears in botanical illustration from 1640 onwards; its red flowers interested Europeans, for whom all previously known columbines had been blue or white. But American flowers can often surprise us:

> *The aquilegia sprinkled on the rocks*
> *A scarlet rain; the yellow violet*
> *Sat in the chariot of its leaves; the phlox*
> *Held spikes of purple flame in meadows wet*
> *And all the streams with vernal-scented reed*
> *Were fringed, and streaky bells of miskodeed.*

'Miskodeed' was the Spring Beauty *(Claytonia virginica)* mentioned under that name in Longfellow's *Hiawatha*.

105. Grape-Hyacinth *(Muscari racemosum)*
FROM *British Entomology*, BY J. CURTIS, 1836

John Curtis the entomologist was not related to William or Samuel Curtis of the *Botanical Magazine*, but at one time of his life he did a good deal of plant-drawing, and in his monumental *British Entomology* each insect is shown with an appropriate flower. A churlish botanist has complained that since only the tops of the plants are usually shown (and the dissections, of course, are those of the insects) the work is of no value to botany; but it would be a carping critic indeed who could not take pleasure in these exquisite miniatures, which deserve to be more widely known.

This little grape-hyacinth is a native of the eastern parts of Britain; if admitted to the garden (as it has been since the sixteenth century) it certainly tends to behave as though it owns the land. Several of the tribe are noted for their scents or smells. The musky scent of *Muscari moschata* from Turkey gave the whole genus its name; it was introduced before 1596, and at one time bulbs of its yellow form sold in Holland for a guinea apiece. *M. botryoides* smells of hot starch, and is sometimes called the Starch Hyacinth; and our little *M. racemosum* has a fragrance of plums. The moth shown alongside is Bentley's Marble Tortrix *(Philalcea juliana)*.

106. Mountain Avens *(Dryas octopetala)*
FROM *British Entomology*, BY J. CURTIS, 1837

In this mother-of-pearl drawing of the Mountain Avens *(Dryas octopetala)* the eight petals that give the flower its specific name are all present and correct; so are the tiny oak-shaped leaves which caused the genus to be named after the dryad or nymph of the oak-tree. In Britain it is a rare survivor of the late Glacial era; and though a native plant, is not despised by even the most sophisticated of rock-gardeners.

104

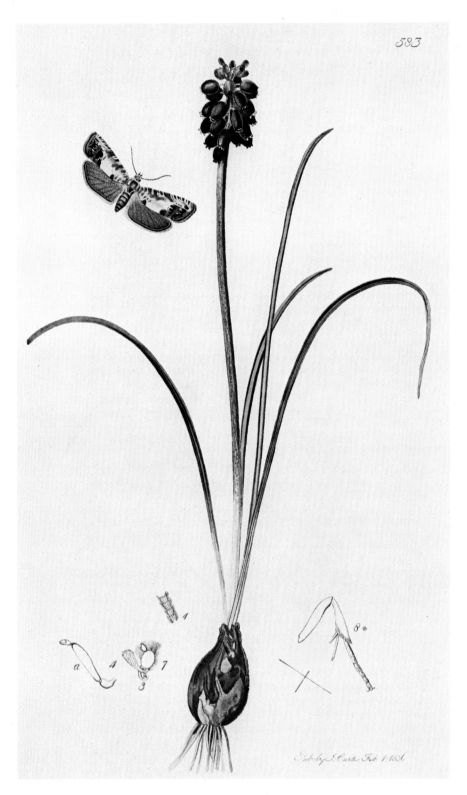

583

105

107. Yellow Water-Lily, Brandy-Bottle *(Nuphar luteus)*
FROM *British Entomology*, BY J. CURTIS, 1834

Curtis puts his most handsome butterflies on the plainest plants or grasses, to avoid competition; but his fifth volume is full of gay flowers and exquisite but not showy little moths with odd names such as the Tabby Knot-Horn or the Beautiful Snout. The two little moths shown with the yellow water-lily are Ringed China-Marks; their larvae roll themselves up, as shown, in sections cut from the leaves of lilies or other water-plants, but 'when they are desirous of removing to any distance' they come out at night, when the predatory ichneumon flies are not about.

The yellow water-lily, though a pleasant flower, is a poor relation compared to its white cousin, and its plebeian name of Brandy-Bottle suits it better than the exotic Nuphar. Formerly both water-lilies were called Nenuphars, a word derived via the Greek and medieval Latin from the Sanscrit name for the blue lotus of India; but now the lovely word is used only by poets.

108. Tiger-Lily *(Lilium tigrinum)*
FROM *L'Antrotrofia ossia la Coltivazione de' Fiori*, BY A. PICCIOLI, 1834

This is the 'Oniyuri', the Ogre Lily of Japan, which has been cultivated for a thousand years in China, Japan and Korea as a food crop, the bulbs being edible. Like the Japanese honeysuckle (see Plate 111), it was introduced via China in 1804 by the Kew plant-collector William Kerr, deservedly commemorated in the Kerria. Formerly regarded as one of the commonest and easiest of lilies, its vitality is now much reduced by susceptibility to virus disease. Wallace, writing on lilies in 1879, described six garden varieties, including a double; he pointed out that it was 'a most useful plant for harvest festival decoration, its time of bloom exactly coinciding'.

109. Carolina Allspice *(Calycanthus floridus)*
FROM *L'Antrotrofia ossia la Coltivazione de' Fiori*, BY A. PICCIOLI, 1834

It was not only in Victorian Britain that the language and sentiment of flowers became popular; in this Italian book each chapter concludes with an 'Emblemata' in verse explaining the flower's significance, and poetical quotations are frequent throughout the text. The drawings are presumably by the author, though only the first few plates are signed by him; he was botanic gardener to the Natural History Museum of Florence.

The Carolina Allspice is grown rather for the spicy fragrance of its bark, leaves and flowers than for its floral display. It was introduced to Britain in 1726, by Mark Catesby, who found it 'in the remote and hilly parts of *Carolina*, but no where among the Inhabitants'; but it remained very rare in gardens until a second importation was made, about 1757.

Pub. by J. Curtis Apr. 1. 1834.

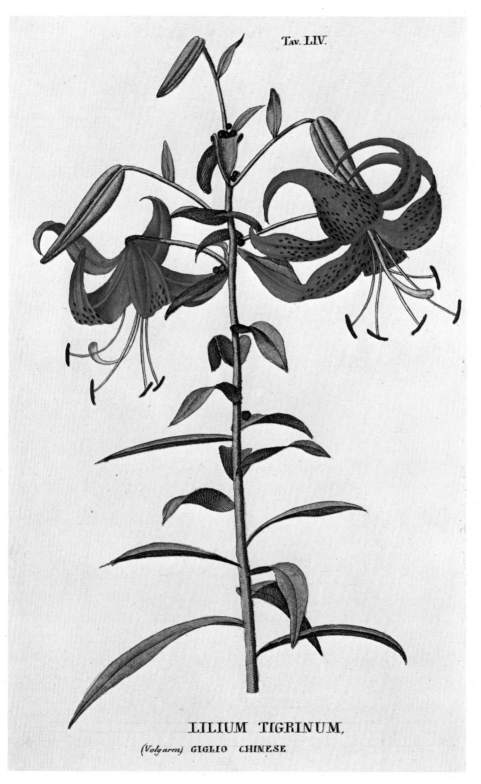

LILIUM TIGRINUM,

(Volgarm) GIGLIO CHINESE

CALYCANTHUS FLORIDUS

(*Volgarm*) POMPADUR.

110. *Mutisia subspinosa*
FROM *The Botanical Miscellany*, BY W. J. HOOKER, 1830

The Botanical Miscellany was the first of several periodicals written or edited by the indefatigable William Jackson Hooker. Hooker was a botanical draughtsman before he became a top-rank botanist, and most of his early illustrations were drawn by himself, and engraved by his Glasgow printer, Joseph Swan. Swan was particularly happy with runners and tendrils, and this example looks as though it had been executed by an expert calligraphist—which is exactly what Swan was.

Bright orange daisies that climb by means of tendrils would be coveted by many gardeners, but unfortunately the South American Mutisias are delicate here, and except for the nearly hardy *Mutisia decurrens* can only be grown under glass. The genus was named after the Spanish José Celestino Mutis (1732–1808), an admirable character who spent most of his life in Colombia, as physician, university professor, astronomer and mining-prospector, but always and predominantly as botanist.

111. Japanese Honeysuckle *(Lonicera japonica)*
FROM *The Botanical Register*, ED. S. EDWARDS, 1815

Like many Japanese plants, this honeysuckle was first introduced from China; it was sent home in 1806 by William Kerr, a collector sent out from Kew. At this time China was closed to Europeans except for the port of Canton, and Kerr could only obtain such plants as were cultivated by the Chinese, who valued this climber for its sweet, almost overpowering scent, more like that of tuberose or orange-blossom than that of the European honeysuckle. They called it Gold-and-Silver Flowers, for the ivory-pale buds darken to yellow as the flower matures—a colour-change characteristic of the family. In England it was grown at first as a conservatory-plant; it is now common in gardens, but does not usually bloom with quite the lavishness of the specimen illustrated. This species is intermediate between the climbing honeysuckles, flowering in terminal clusters, and the shrub-honeysuckles, which bear flowers in pairs in the leaf-axils.

112. Spring Star-Flower *(Ipheion uniflora)*
FROM *The Botanical Register*, ED. J. LINDLEY, 1837

This is one of the plates drawn for the *Register* by the mysterious Miss Drake, a lady whose unfeminine style often shows a sinewy strength like that of a ballet-dancer, where grace depends on iron muscles underneath.

Her 'Tritelia' depicts one of the most elegant spring flowers, its only flaw the smell of garlic with which it retaliates when roughly handled. It needs some means of defence, having been pushed about by botanists from one genus to another, and called many names, of which the present 'Ipheion' is possibly not the last. Surprisingly, this charming plant is completely hardy, although it is a native of Buenos Aires, whence it was introduced by the Scottish plant-collector James Tweedie in 1832. The flower-colour varies from the typical bluish-white with smart violet markings to a fairly deep lavender.

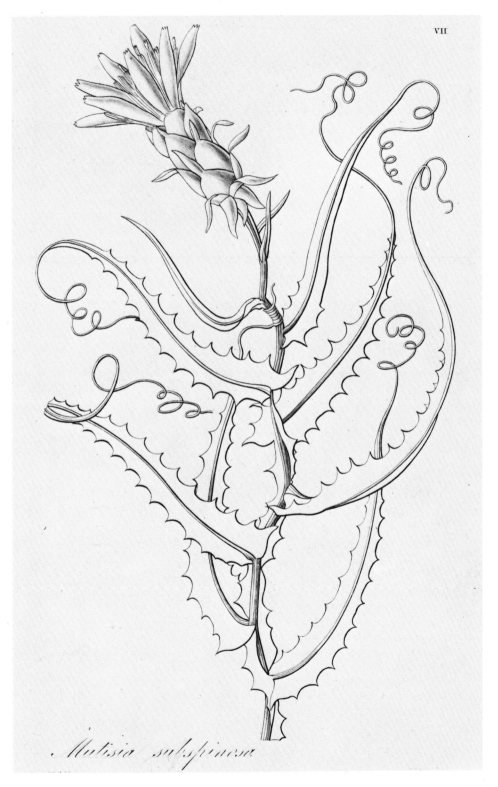

Mutisia subspinosa

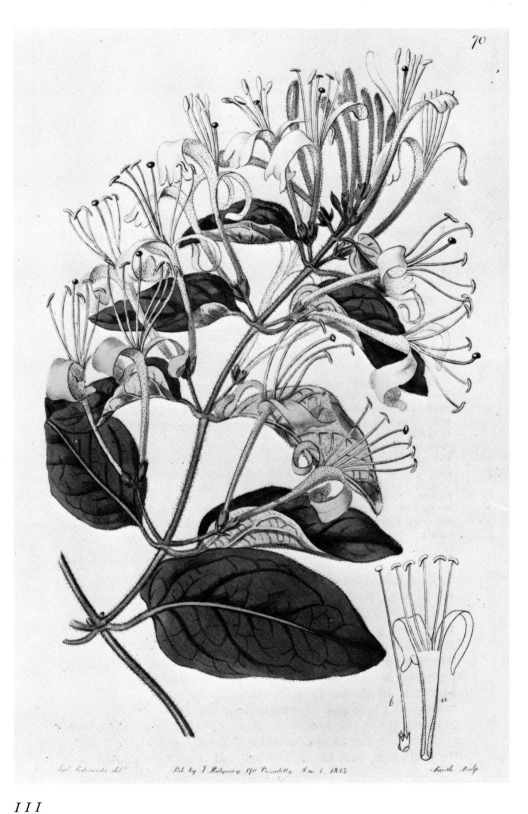

70

III

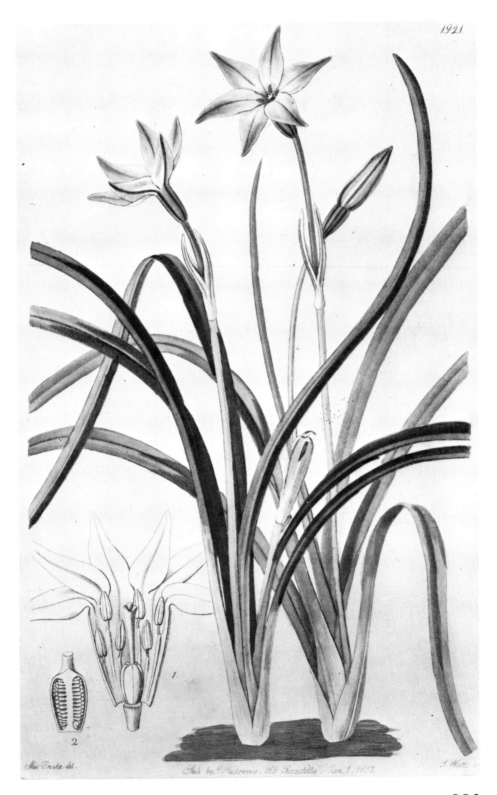

Pub. by J. Ridgway, 169 Piccadilly. Jan. 1. 1837.

113. Pelargonium varieties
FROM *The Romance of Nature*
BY LOUISA ANNE TWAMLEY (MRS MEREDITH), 2ND EDN, 1836

This book, justly called 'a very elegant work on flowers', was dedicated to Wordsworth, 'with his kind permission'. Both verses and illustrations were the work of Miss Twamley of Birmingham, and the drawings, at least, show a considerable degree of talent. The authoress loved flowers 'as forming one of the sweetest lines in the GOD-WRITTEN Poetry of Nature', and endeavoured to draw them with the strictest accuracy. 'My models always appeared to me too perfect in their beauty for me to dream of doing aught but attempt to copy, as faithfully as I can, their forms and colours.'

Pelargoniums at that time were exceedingly popular, and many varieties were grown (see Plate 67 and note). Ladies would send their favourite plants when in bloom to a nurseryman, to be placed near other species or varieties, in the hope that their seeds would produce new kinds. Those illustrated were called 'Anne Boleyn' and 'Caractacus'.

114. Bog Asphodel *(Narthecium ossifragum)*
FROM *British Phaenogamous Botany*, BY W. BAXTER, 1837

For nearly forty years William Baxter was curator of the Oxford Botanic Garden, and his book ('Phaenogams' meaning simply flowering plants) was intended mainly for the use of students. Hooker mistakenly stated that the work was never completed, 'Mr Baxter having died after the third number'; Loudon, correcting this, said it was the book, not the botanist, that had died; but actually both survived, the book to complete its sixth volume and Baxter his eighty-fourth year.

The attractive little bog-asphodel (which is not really an asphodel, though it resembles one) received its specific name of 'ossifragum', bone-breaker, because of the belief that it made the bones of cattle that fed upon it frail and brittle. In Norway, indeed, it was said to render the bones of oxen so soft that not only were the poor beasts unable to walk, but they could be rolled up and moulded into any desired shape. It is true that the bogs in which the plant grows are unwholesome for cattle—but for other reasons.

115. Sea Pea *(Pisum maritimum)*
FROM *British Phaenogamous Botany*, BY W. BAXTER, 1837

Not only herbalists and botanists, but chroniclers such as Stowe, Camden and Fuller, tell the story of the Sea Pea, which in 1555, a year of crop-failure and great dearth, miraculously appeared (or was discovered) upon the Suffolk coast between Aldeburgh and Orford, and saved the lives of many starving villagers. 'There chaunced in this barraine place sodainly to spring uppe without any tillage or sowing, great abundaunce of Peason, whereof the poore gathered (as men judged) about a hundred quarters.' The coastline of the region has been much changed by erosion, and half of Tudor Aldeburgh is now under the sea; but the pea has shifted with the pebbles, and still spreads over the shingle a Persian carpet of dark leaves and richly coloured flowers. Nobody needs to eat it now.

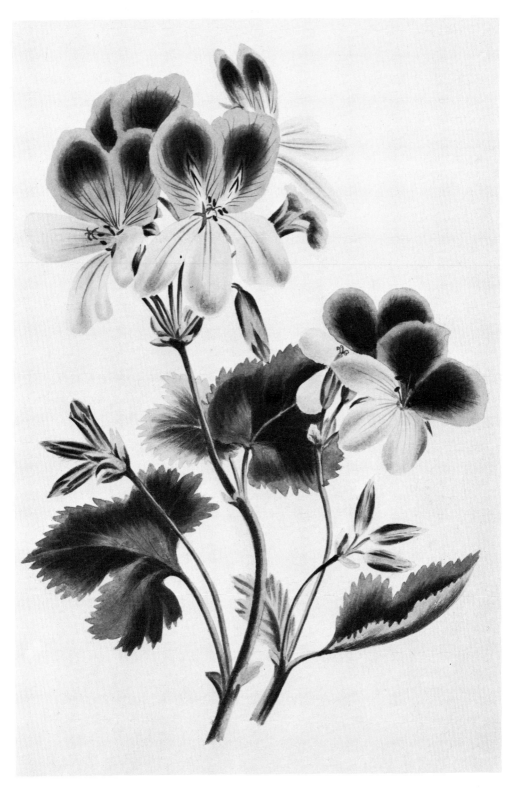

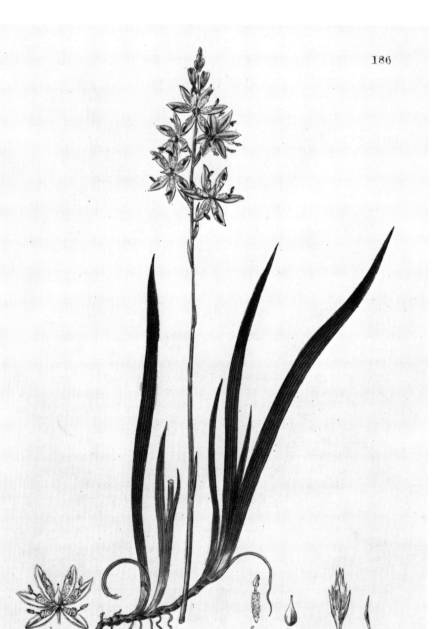

Narthecium ofsifragum. Lancashire Bog-Asphodel. 4

Pub.ᵈ by W.Baxter, Botanic Garden, Oxford, 1836.

C.Mathews.Del.&,Sc.

114

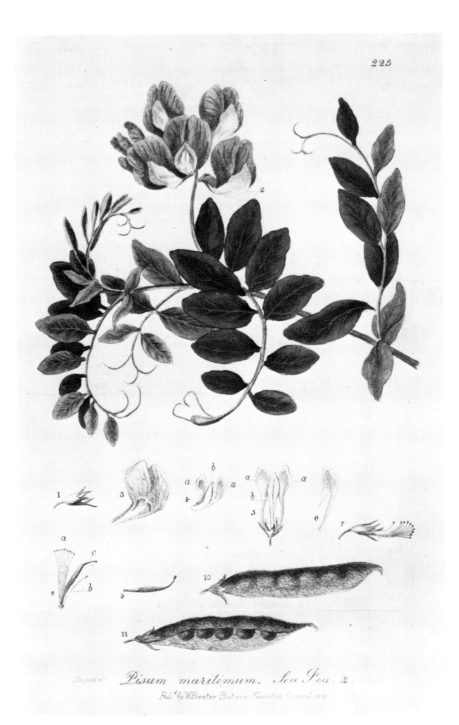

Pisum maritimum. Sea Pea.

Pub.^d by W.Baxter Botanic Garden Oxford 1837.

116. Water-Lily *(Nymphaea odorata)*

FROM *The Genera of the Plants of the United States*, BY A. GRAY AND I. SPRAGUE, 1848

The renowned American botanist Asa Gray compiled this book chiefly as a vehicle for the brilliant plant-drawings of Isaac Sprague; but on most of the plates the flowers are torn to pieces and smothered among their own botanical dissections. In the case of the water-lily, however, a separate plate is devoted to these fragments, and we are allowed to enjoy the flower and the draughtsmanship unimpeded.

Nymphaea odorata is closely allied to the European *N. alba*, with the added advantage of fragrance; the name is derived from the water-nymphs that were believed to frequent its habitat. In Scandinavia the roots of the European sort were formerly used to make an 'électuaire de chasteté' used in convents and monasteries; but in Sweden they were also used as a food, and as has been pointed out there are still plenty of Swedes, and more are born every day.

117. Indian Crocus *(Pleione praecox)*

FROM *The Botanical Magazine*, ED. W. J. HOOKER, 1850

We have reproduced the first plate issued by the *Botanical Magazine* in 1787; the present subject is chosen, not from the last volume, which happily is not yet in sight, but from the last to fall within the limits of our period. By this time, under the direction of Dr W. J. Hooker (see Introduction), the character, though not the format, of the magazine had greatly changed. The 1850 volume is almost entirely devoted to greenhouse and stove plants, many of them so fantastic that it seems incredible that they were ever cultivated.

The Pleiones, however, are familiar to many gardeners, as they are both beautiful and easy to grow. Some of the species will even grow out-of-doors in Britain, but like juvenile delinquents must always be regarded as in need of care and protection. *P. praecox* is a native of the Himalayas, and was first discovered by Nathaniel Wallich in 1815.

118. Garden Fuchsia *(Fuchsia × chandleri)*

FROM *Popular Flowers*, BY R. TYAS, 1843

The Reverend Robert Tyas was a clergyman of East Tilbury, in Essex, who produced a litter of small flower-books in the early years of Victoria's reign, usually illustrated by James Andrews. His *Popular Flowers* was issued as a series of pamphlets (price 6d), each with a coloured frontispiece; the second edition had a different and superior set of plates. Both sets of figures were unsigned, and in both cases the artist had the pleasing habit of writing the name of the variety on the stem of the flower.

In this case 'Fuchsia chandlerii' is just discernible, showing the variety to be one of those raised by the firm of Chandler and Buckingham at Vauxhall. At that date hybrid fuchsias with white corollas were very new indeed; the first, 'Venus Victrix', had bloomed in 1840, only three years before. *F. × chandleri* is said to have been raised from a seed of *F. fulgens*, but apparently has since been lost.

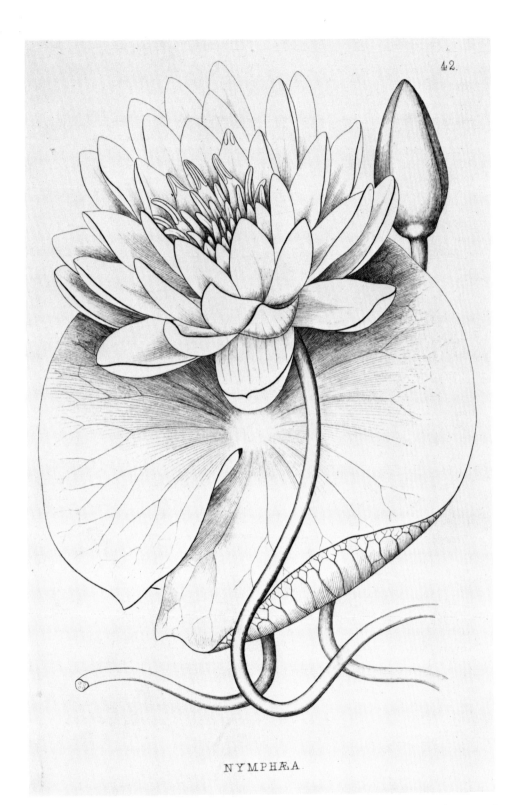

NYMPHÆA.

Fitch del et lith. Reeve Benham & Reeve, imp.

117

118

Index of Persons

The figures in italics refer to the descriptive notes to the plates.

———